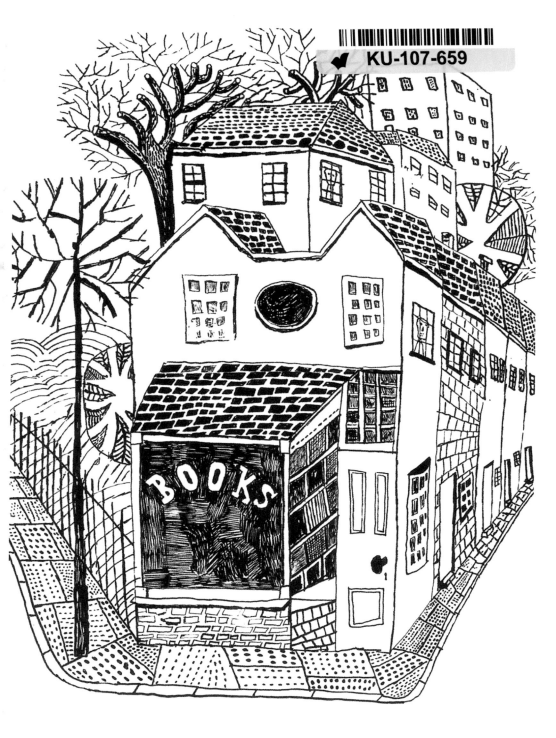

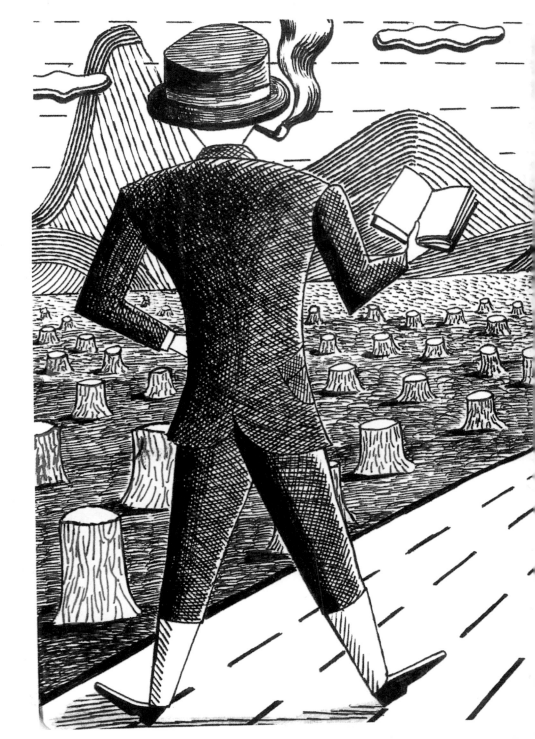

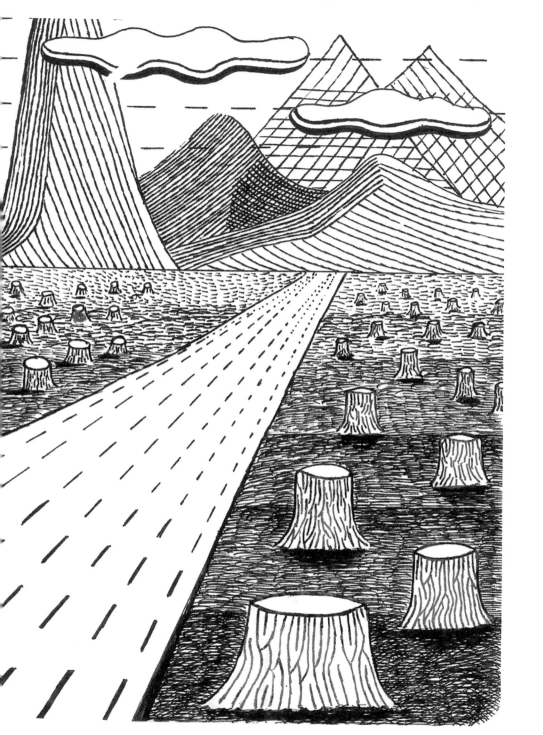

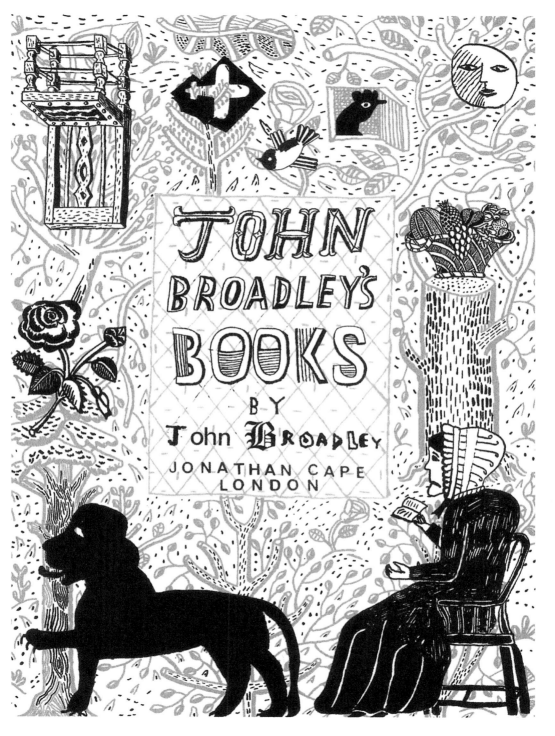

JOHN BROADLEY'S BOOKS

BY

John Broadley

JONATHAN CAPE
LONDON

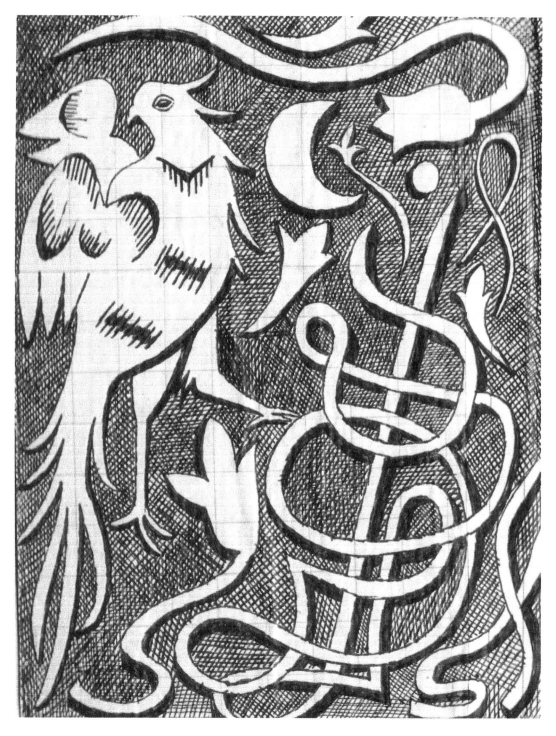

CONTENTS

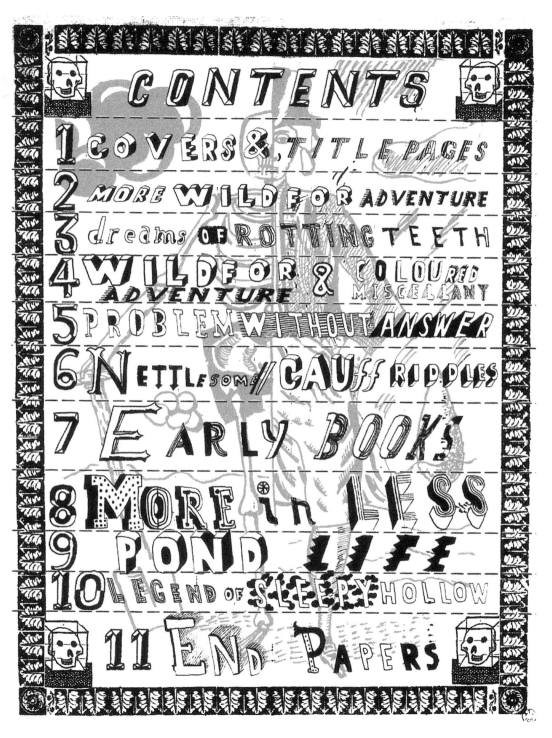

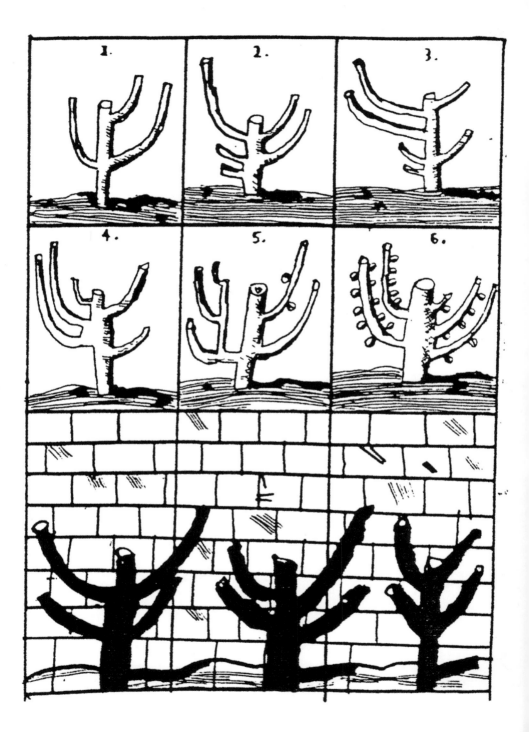

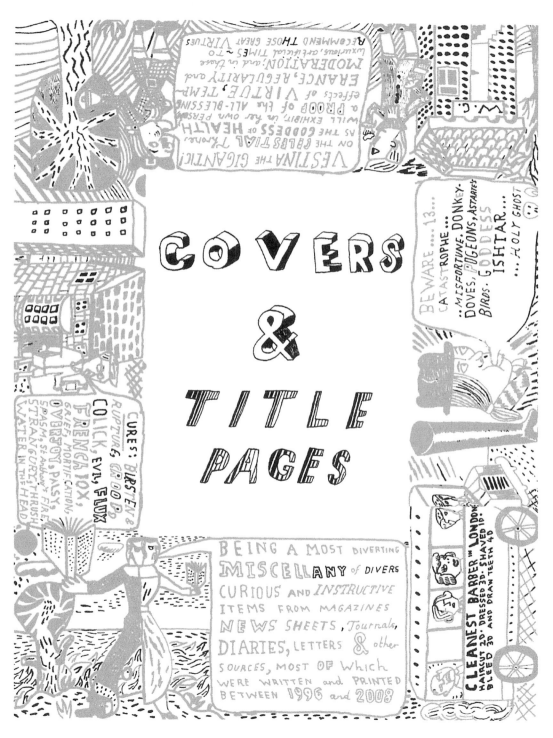

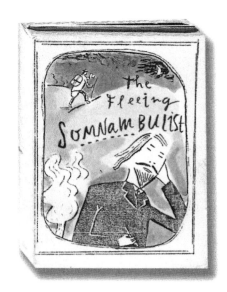

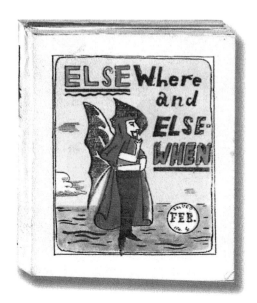

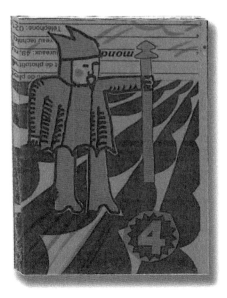

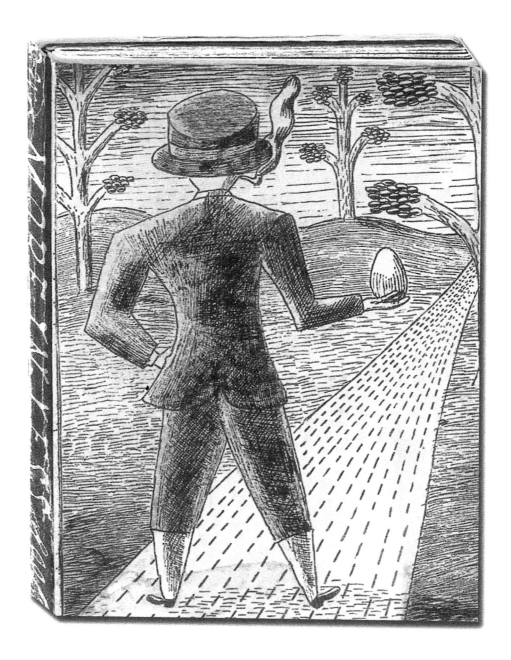

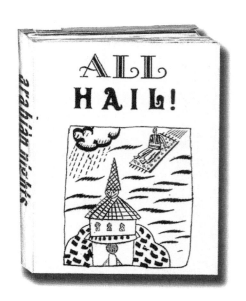

ALL HAIL!

arabian nights

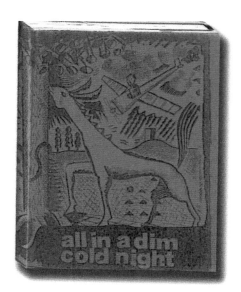

all in a dim cold night

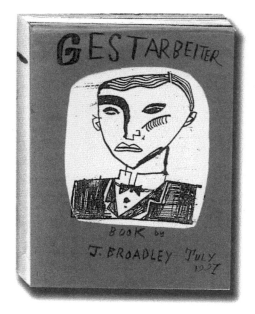

GESTARBEITER

BOOK by
J. BROADLEY JULY
1987

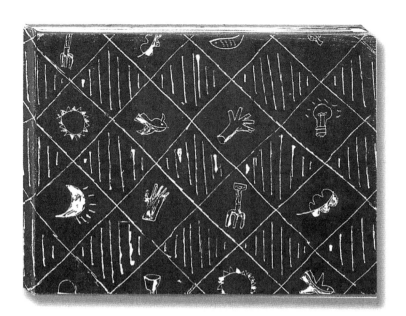

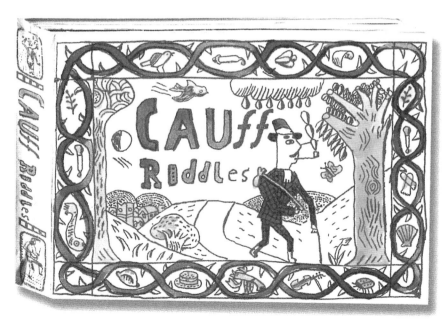

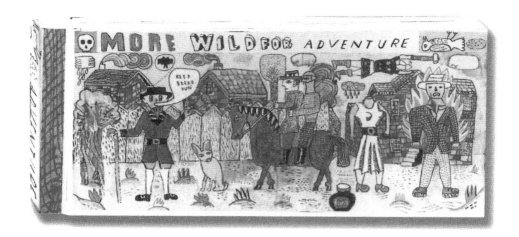

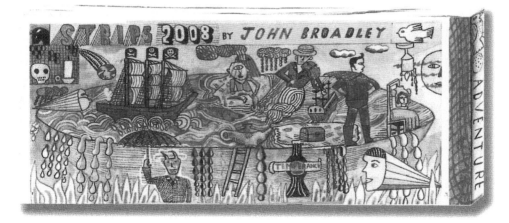

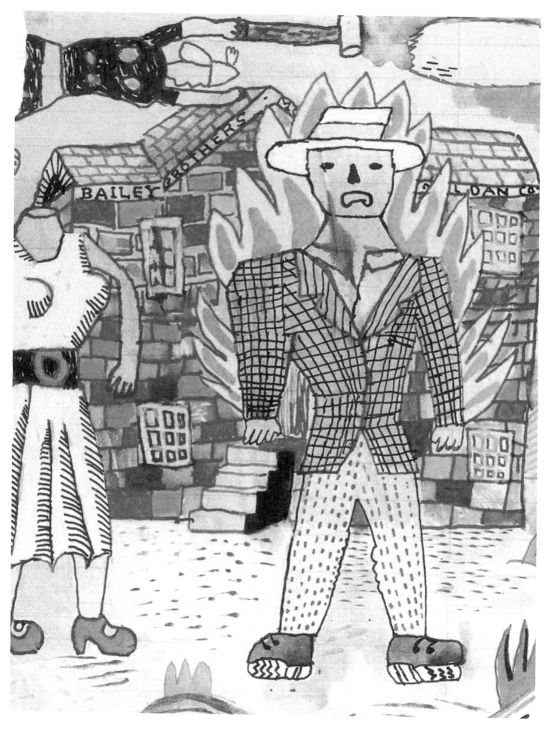

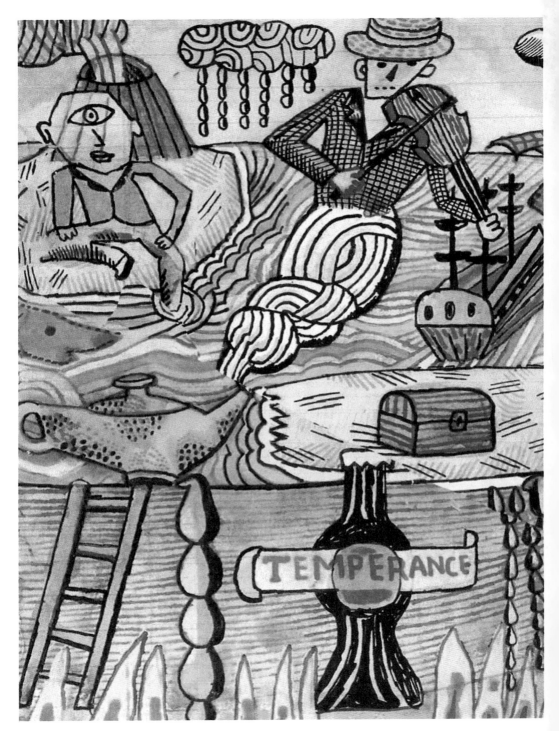

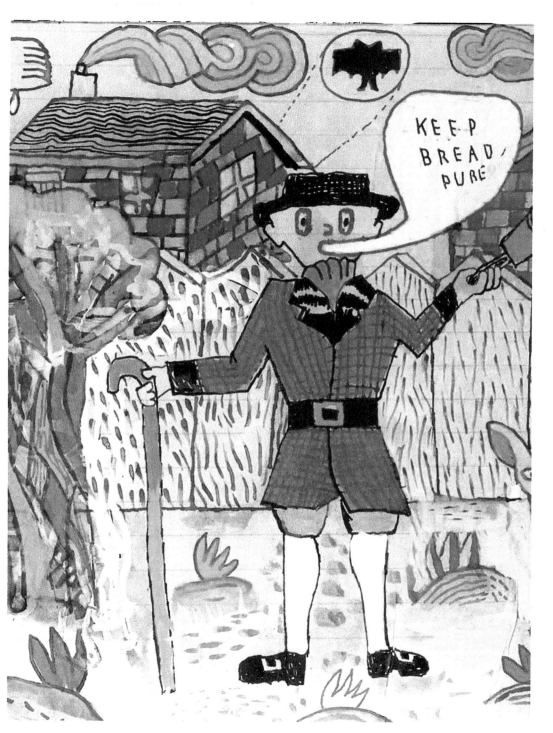

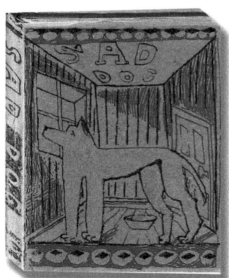

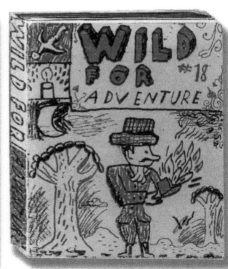

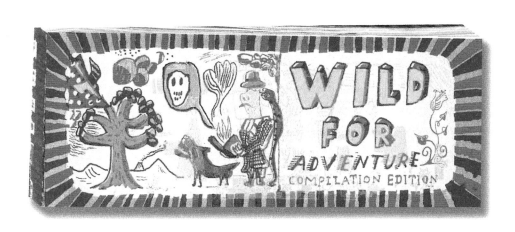

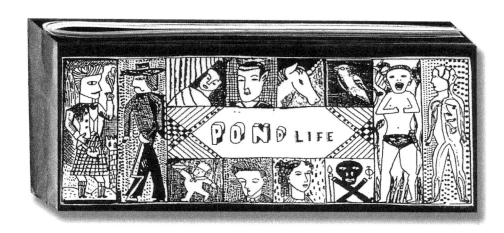

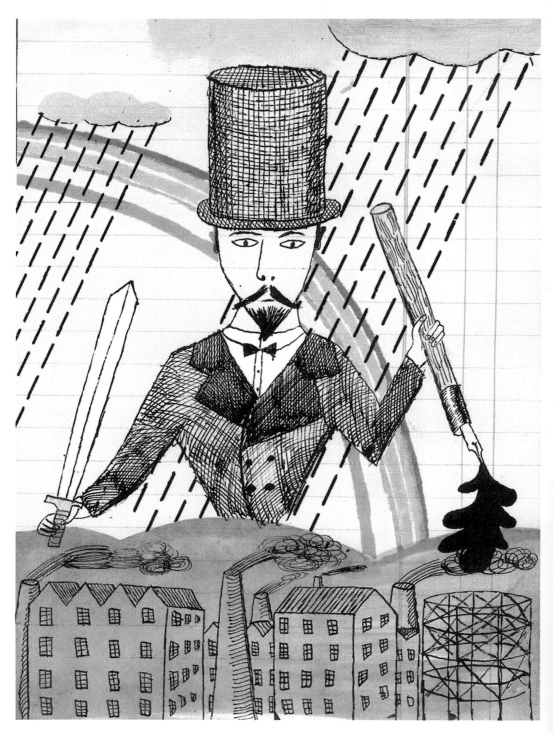

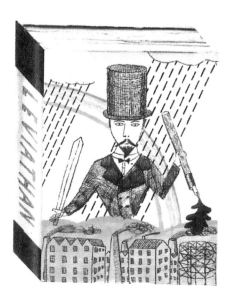

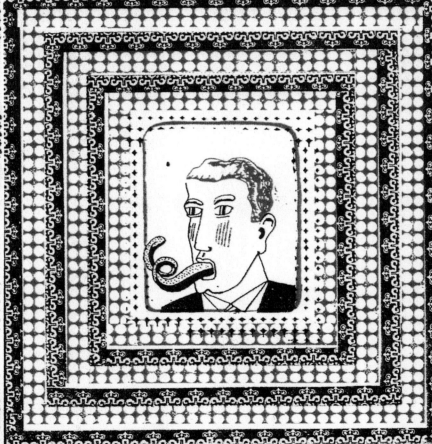

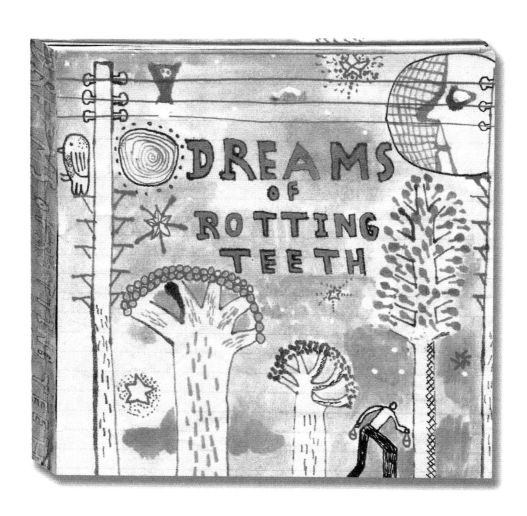

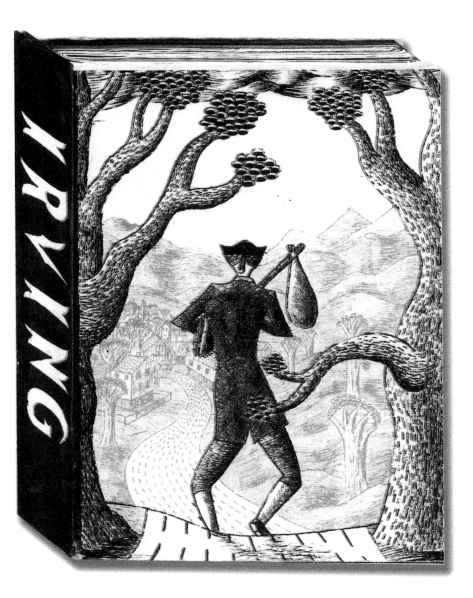

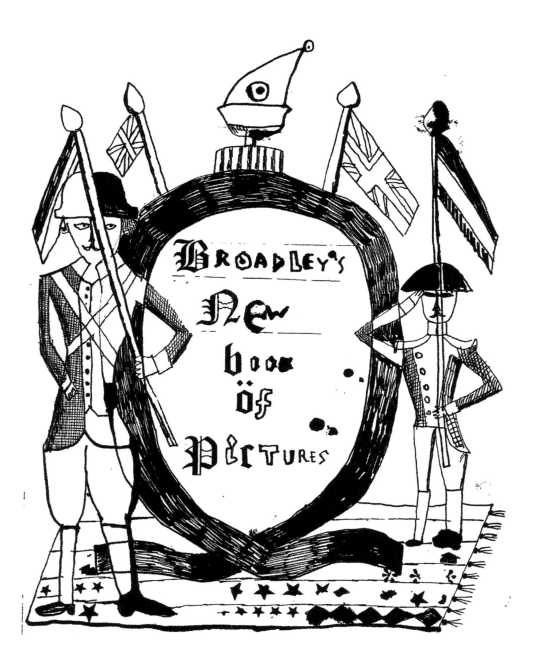

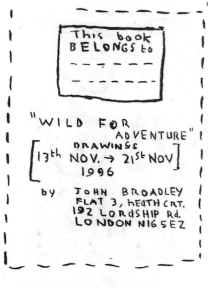

This book
BELONGS to
_ _ _ _ _ _ _
_ _ _ _ _ _ _

"WILD FOR
ADVENTURE"
DRAWINGS
[13th NOV. → 21st NOV]
1996

by JOHN BROADLEY
FLAT 3, HEATH CRT.
192 LORDSHIP Rd.
LONDON N16 5EZ

"LOCK YOUR DOORS"
ISSUE DATED
18TH DEC. 1996

BY JOHN BROADLEY

THIS BOOK BELONGS
TO:

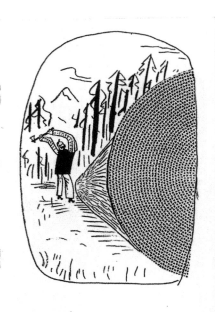

ELSEWHERE AND ELSEWHEN

This copy belongs to:

— — — — — — — —

13th 14th FEB. 1997

by JOHN BROADLEY
Flat 3, HEATH COURT
192 Londship Road
London N16 5EZ

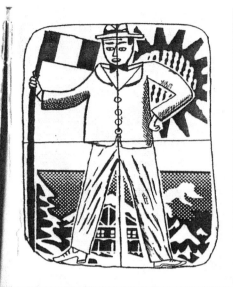

"THE FLEEING SOMNAMBULIST"
a book of DREAMS & OMENS

ISSUE NUMBER 3 IN the
COLLECTION OF
DRAWINGS BY JOHN BROADLEY

this COPY
BELONGS to:

— — — — — — — —

CONCEIVED + CONSTRUCTED
14th → 15th JANUARY
1997.
AT: FLAT 3, HEATH COURT
192 LORDSHIP ROAD
LONDON N16 5EZ

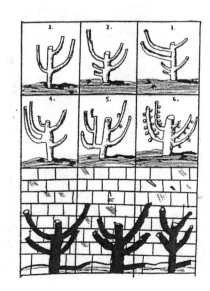

JUNE
97

1001

NIGHTS

JOHN BROADLEY

MAY 1998

TURN
OVER A
NEW
LEAF

THIS BOOK BELONGS TO :

-- -- -- -- -- -- -- -- -- -- -- -- -- -- -- --

SPELLS fortune Luck

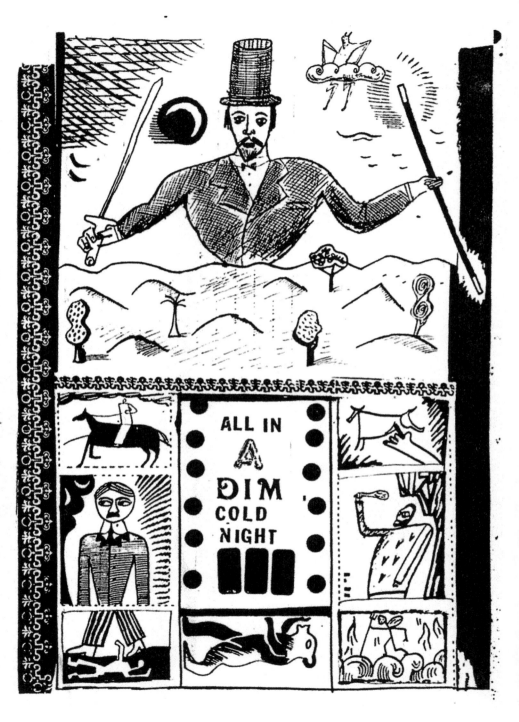

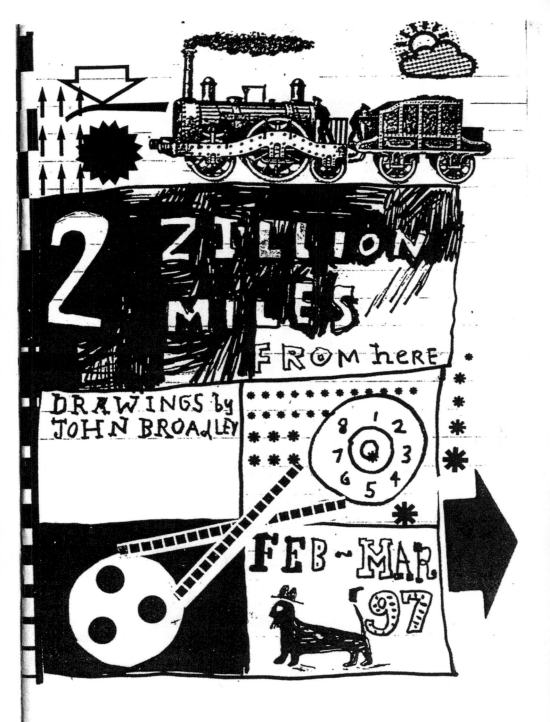

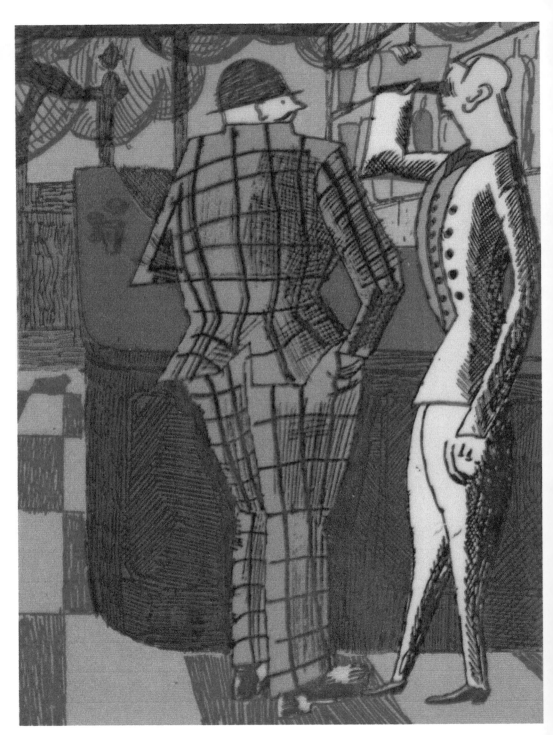

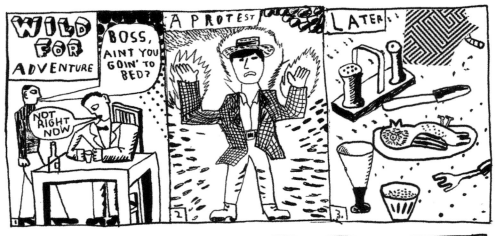

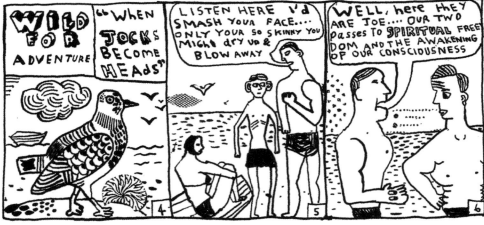

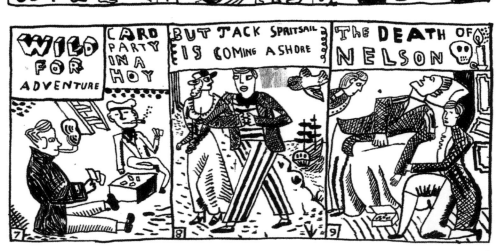

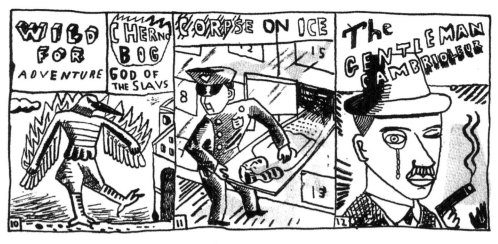

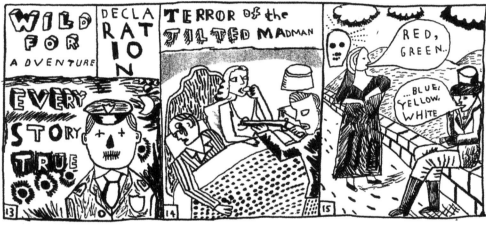

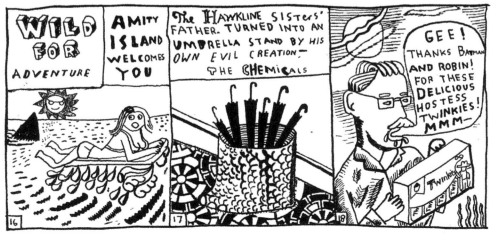

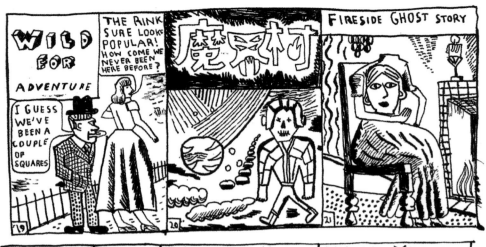

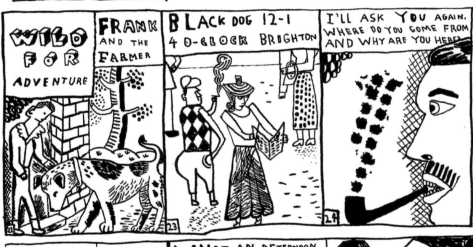

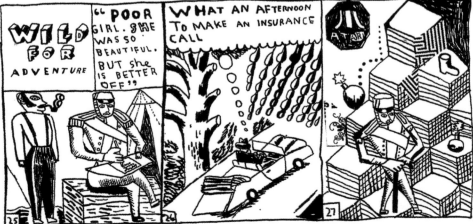

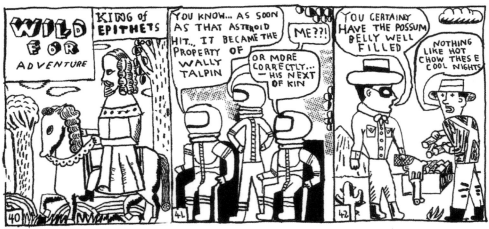

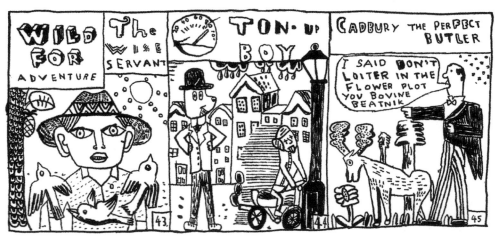

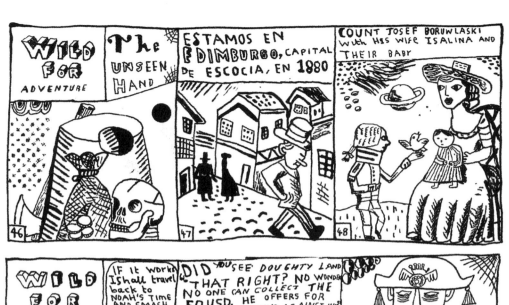

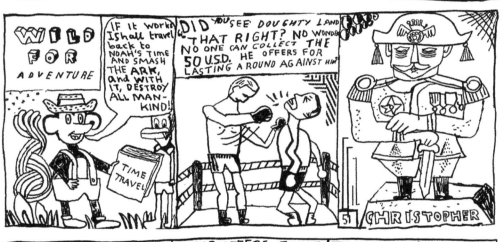

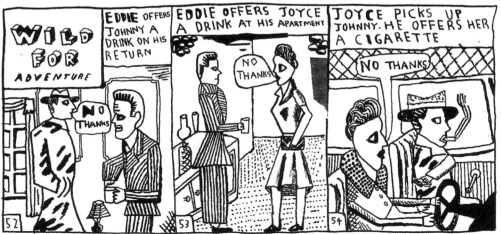

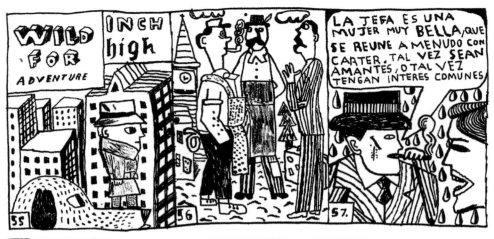

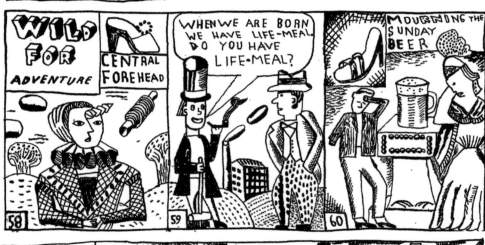

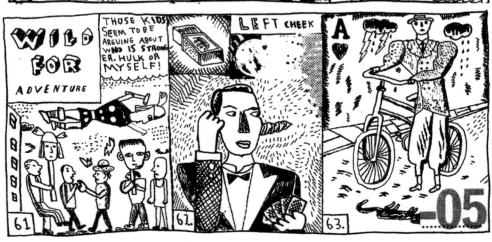

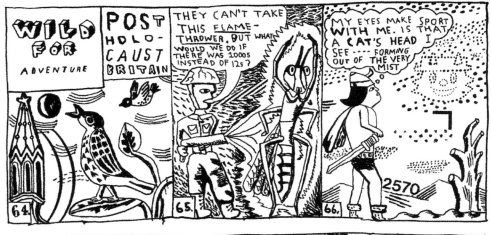

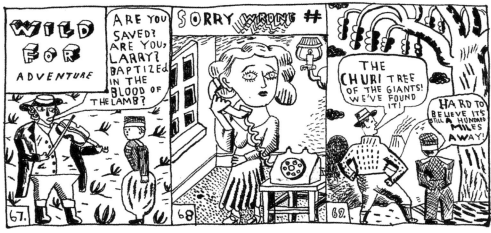

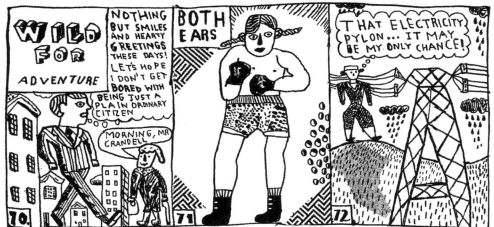

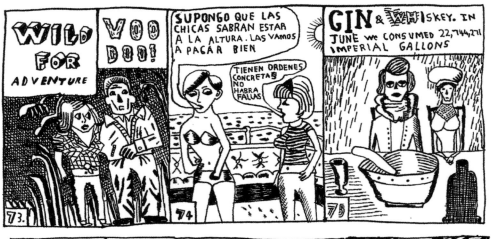

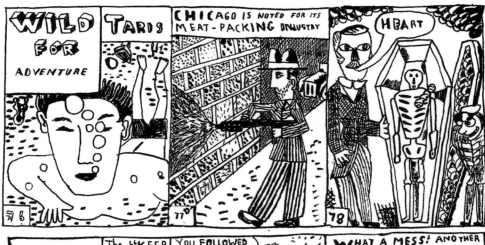

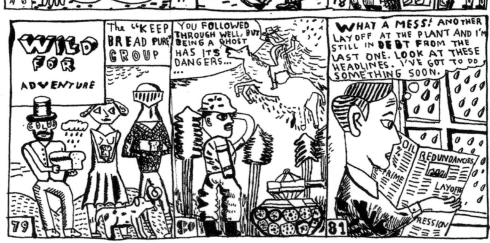

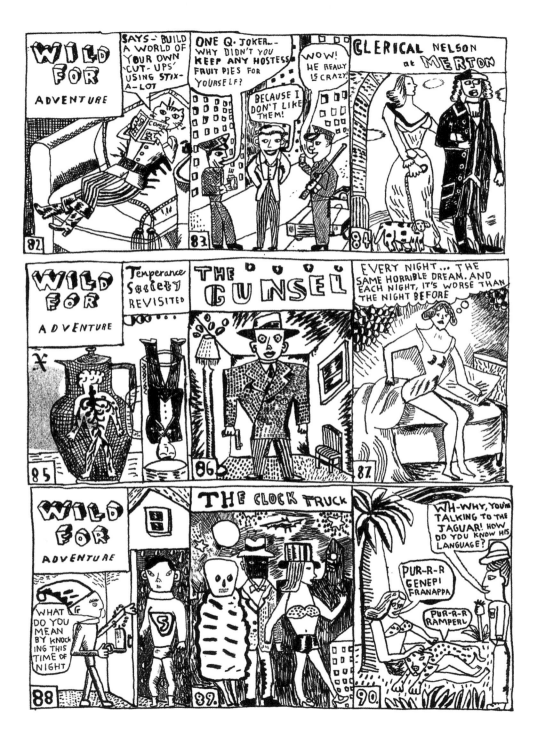

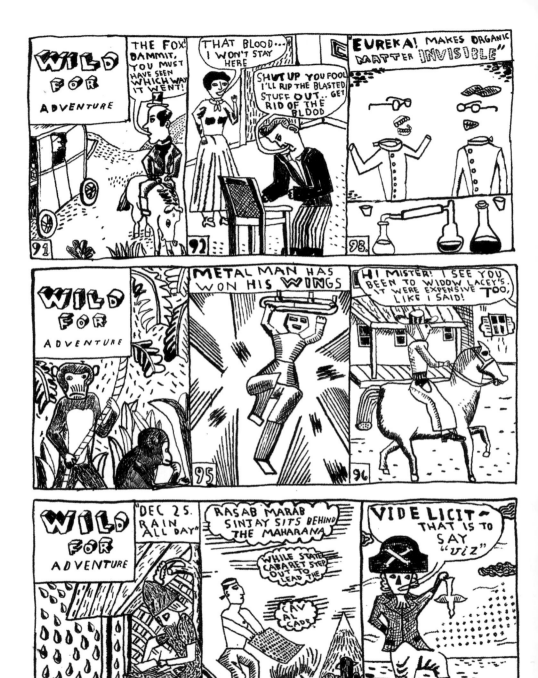

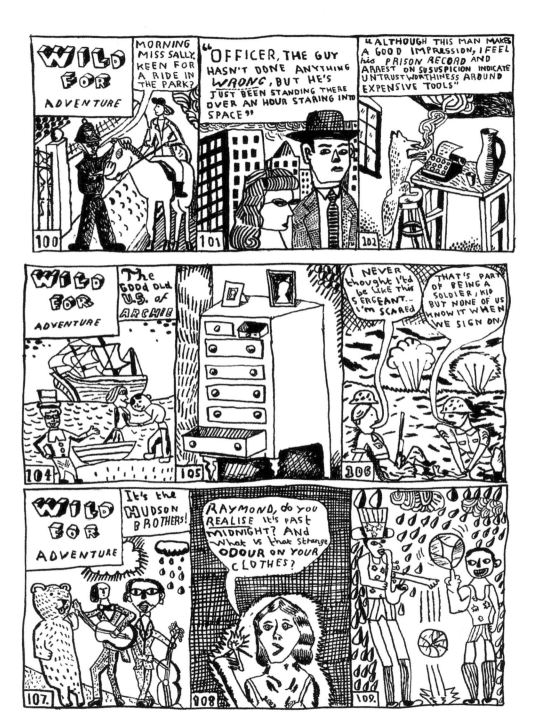

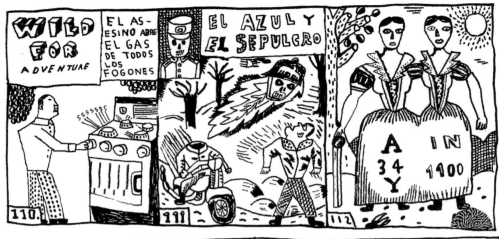

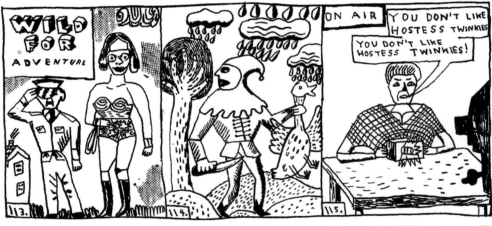

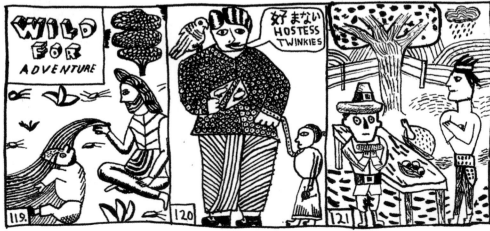

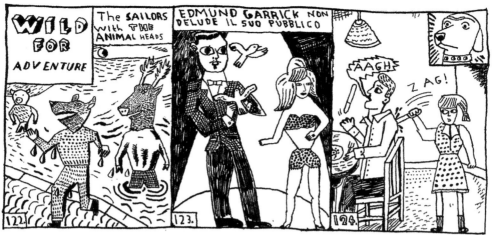

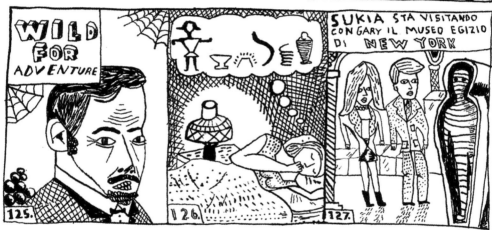

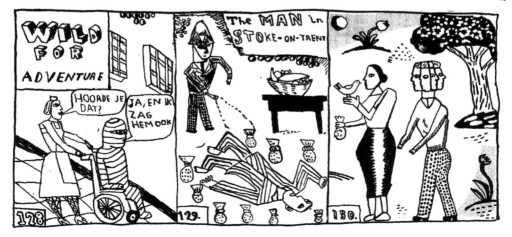

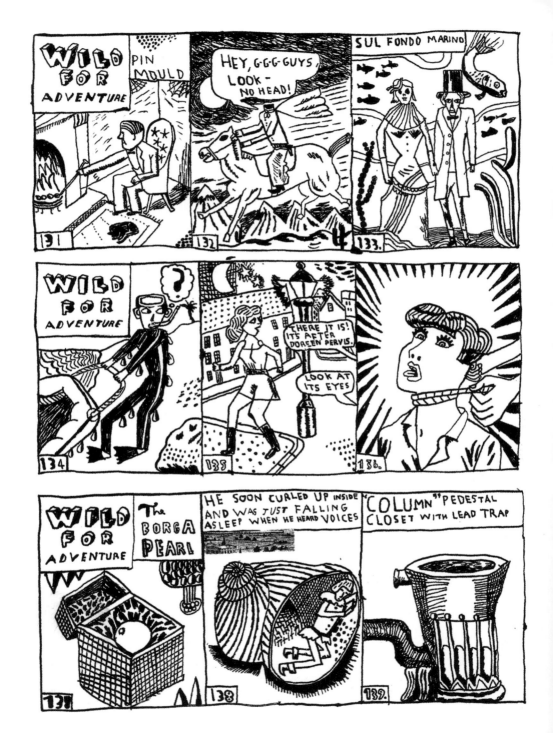

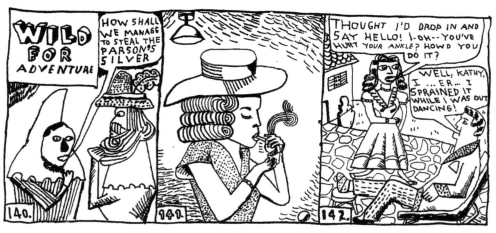

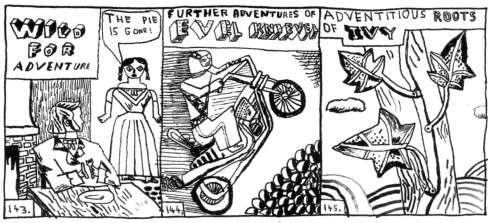

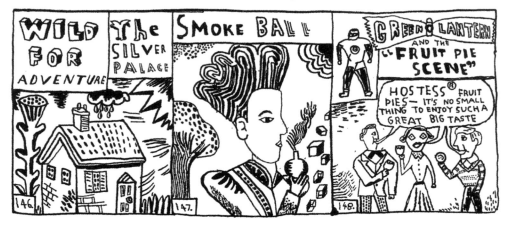

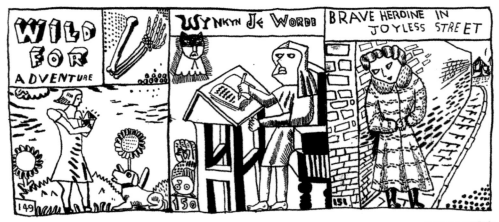

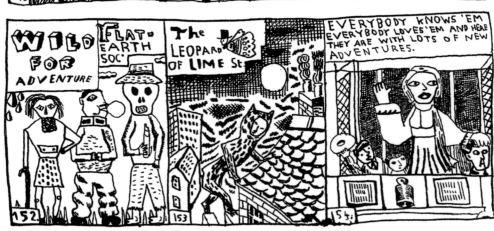

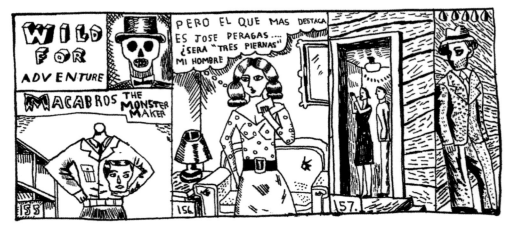

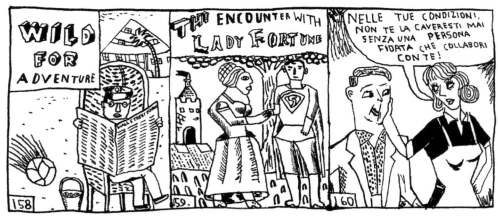

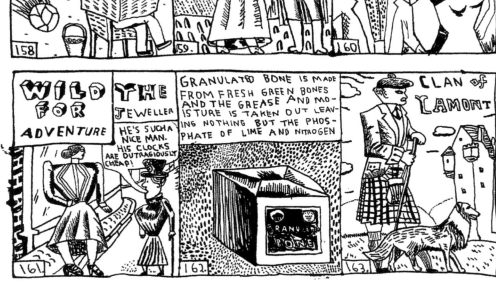

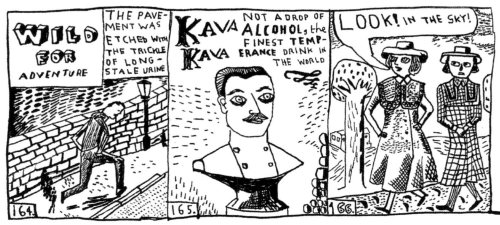

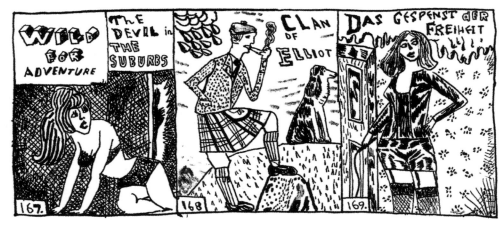

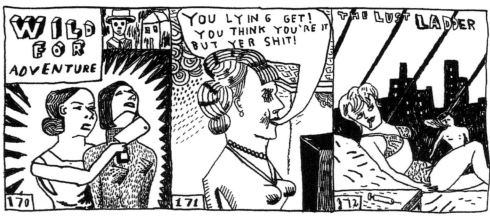

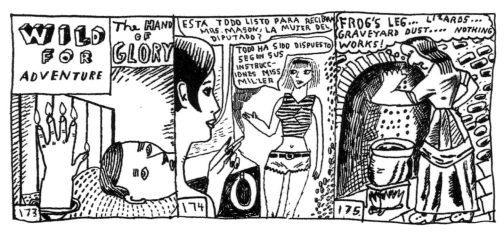

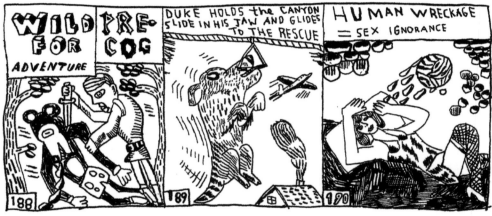

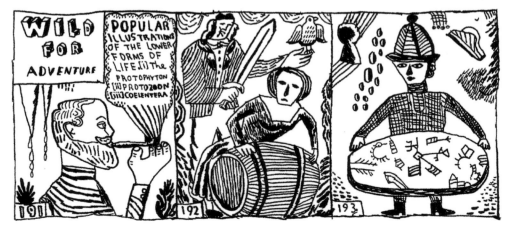

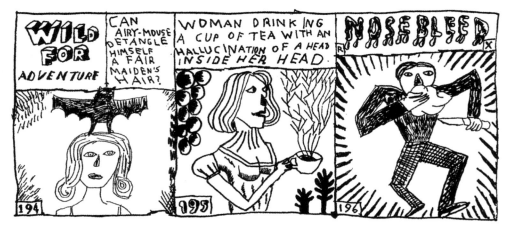

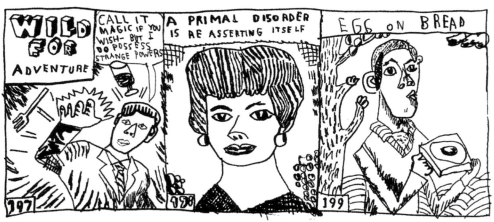

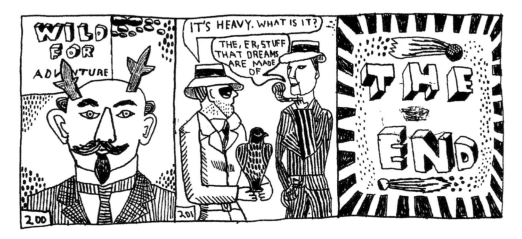

dreams

OF

ROTTING

TEETH

ALICE WAS BEGINNING TO GET VERY TIRED OF SITTING BY HER SISTER ON THE BANK, AND OF HAVING NOTHING TO DO

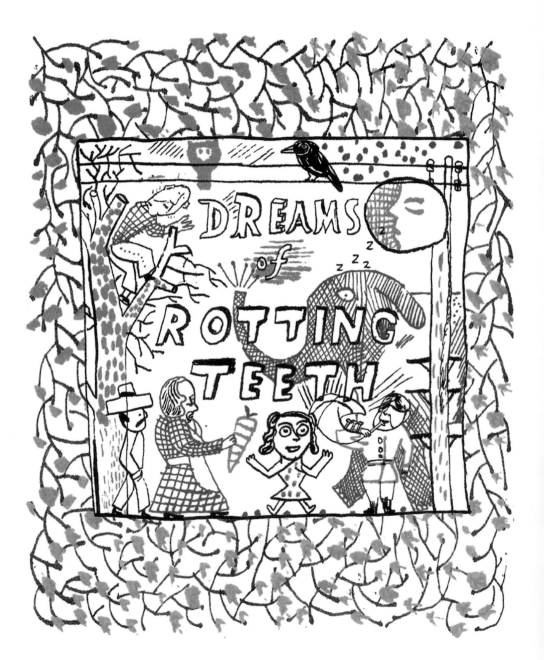

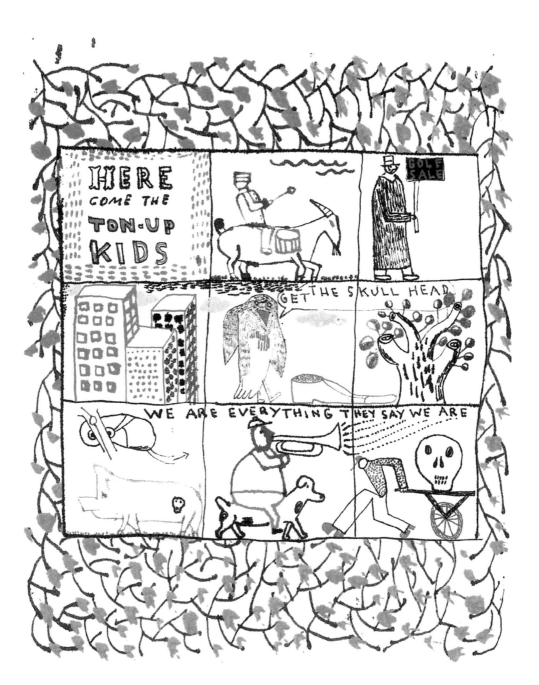

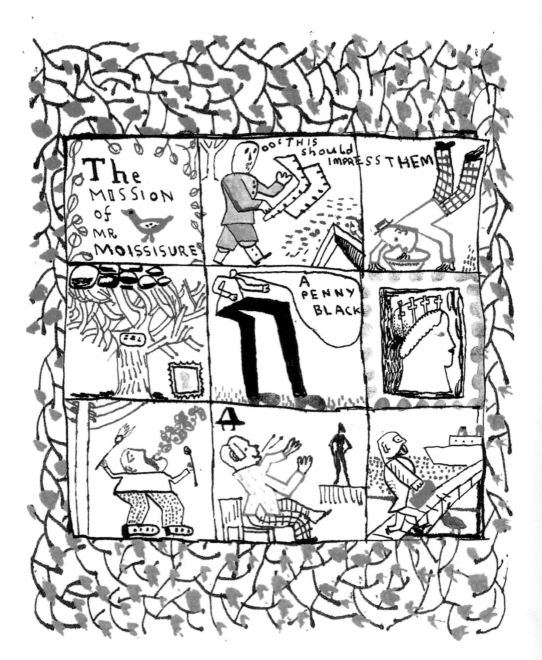

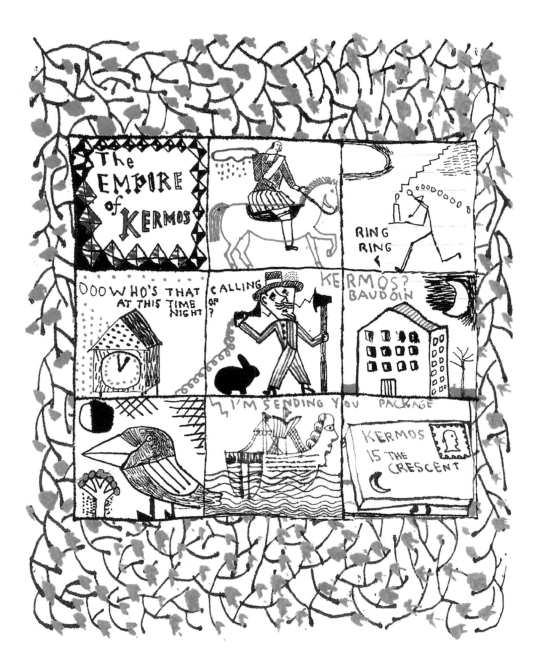

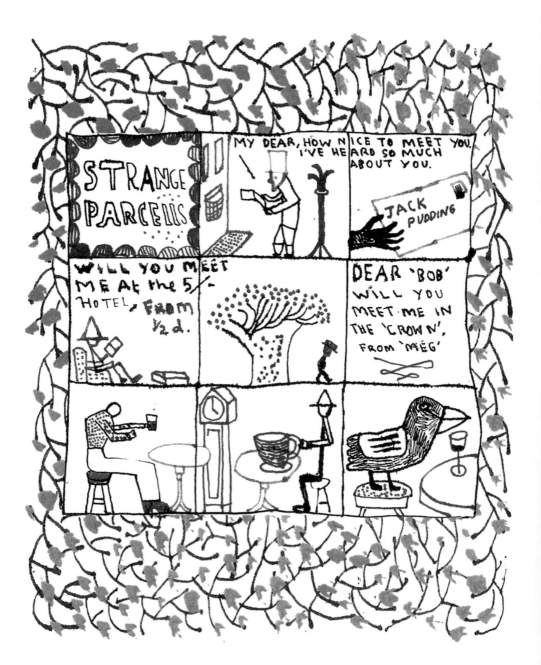

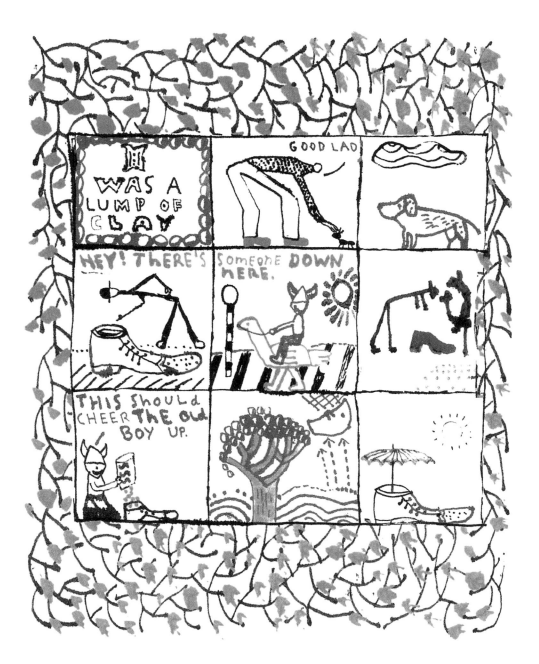

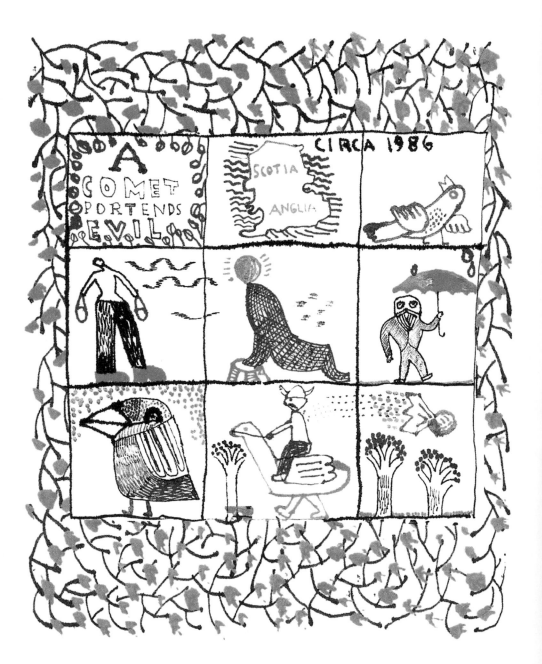

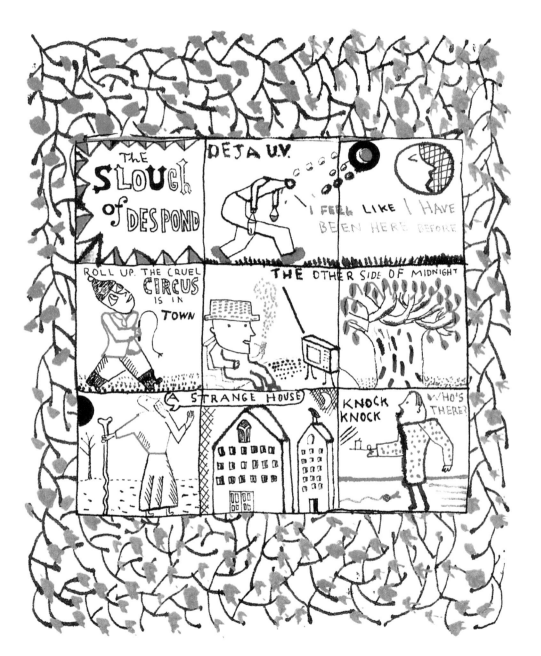

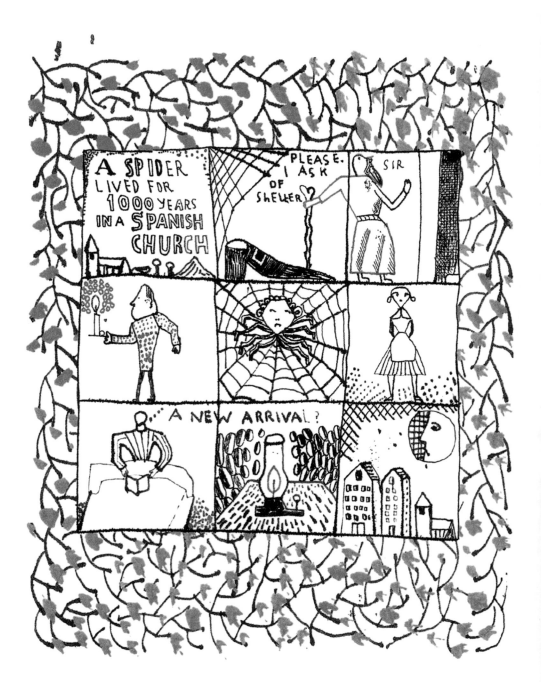

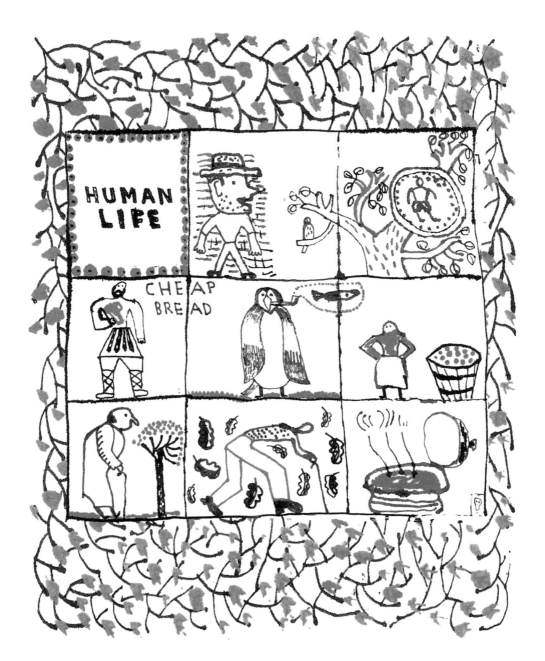

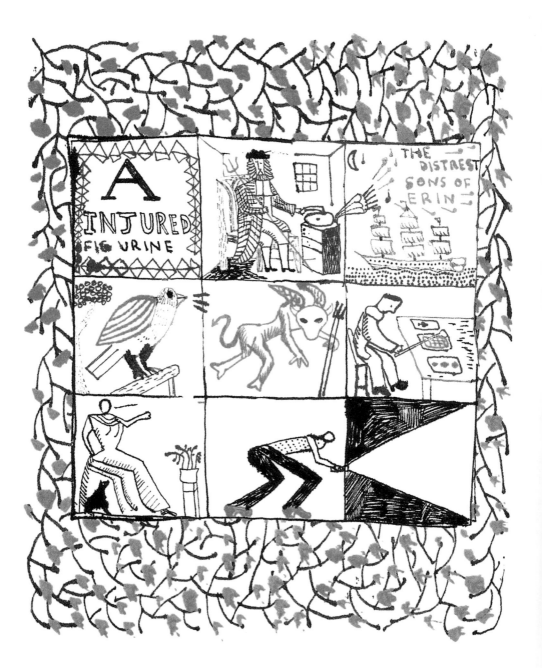

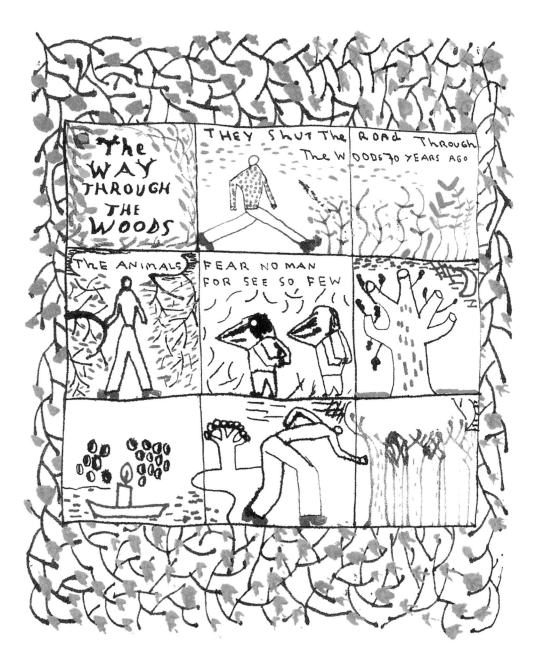

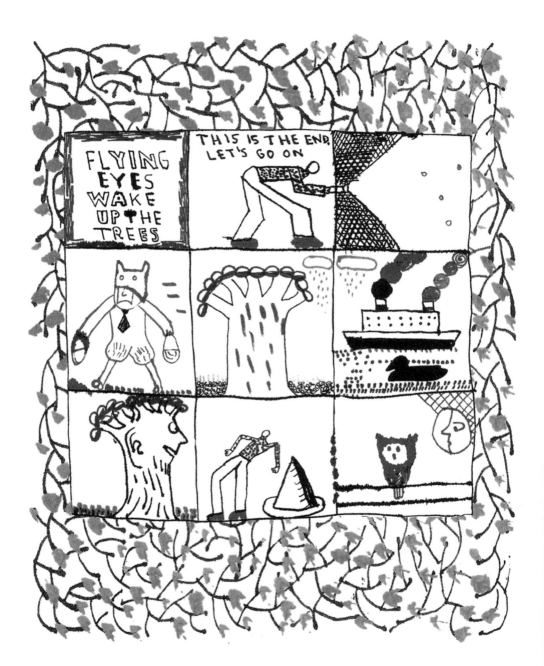

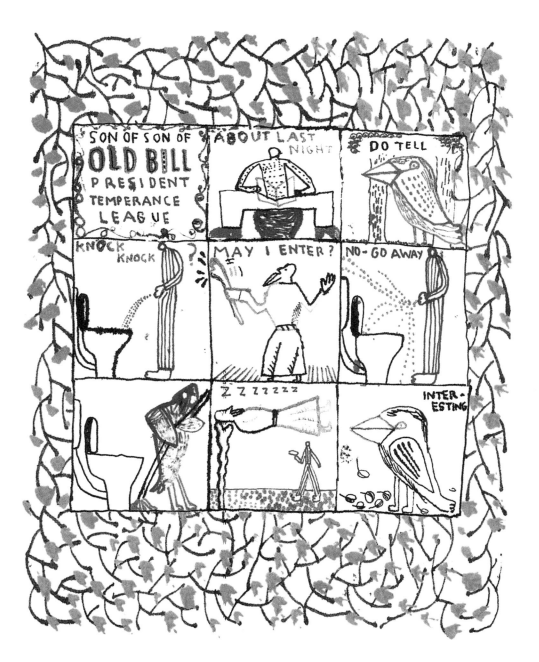

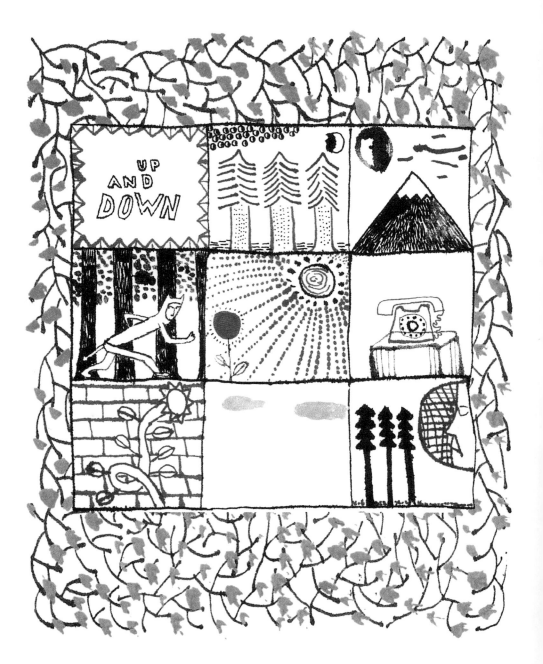

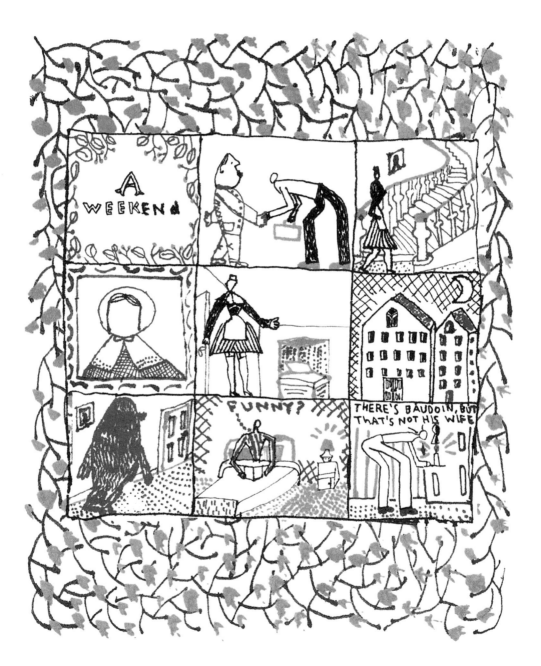

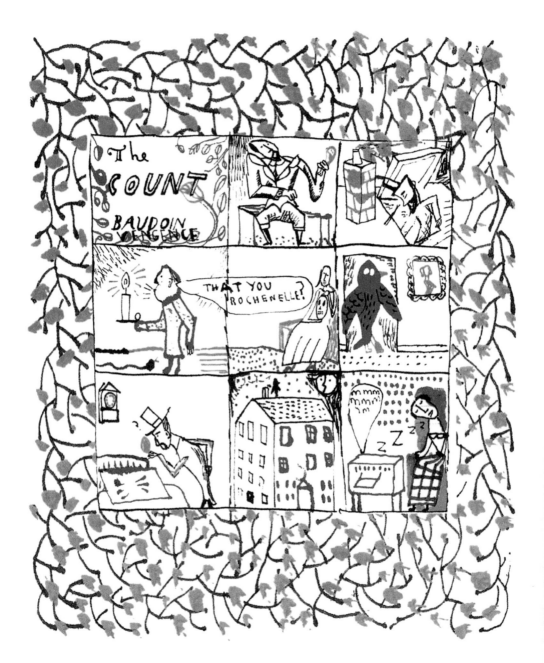

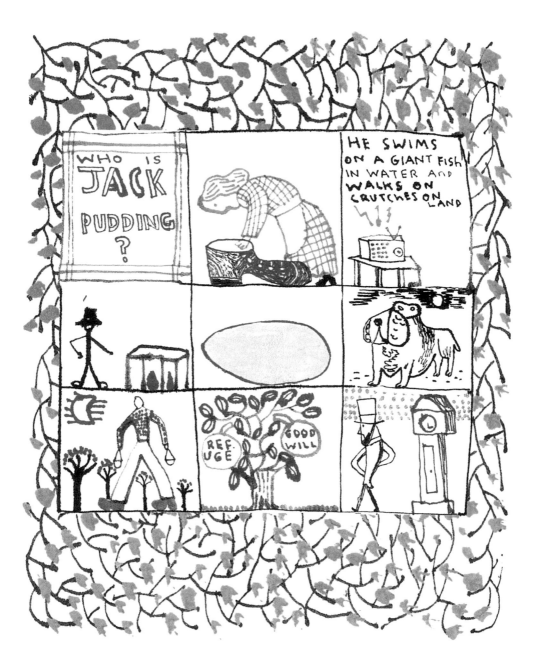

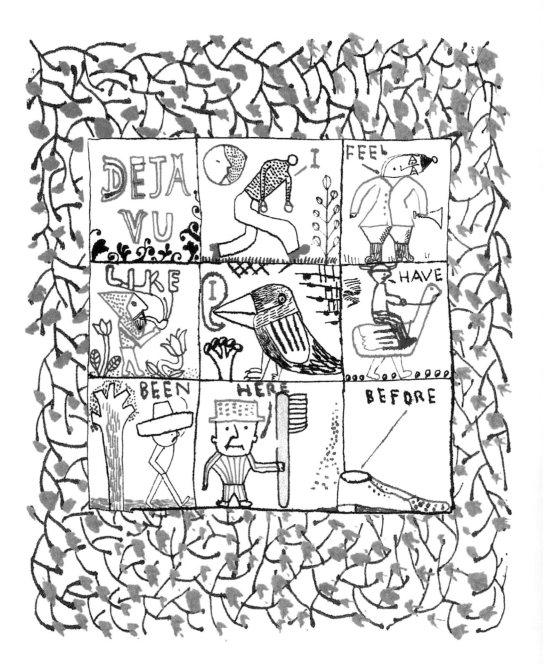

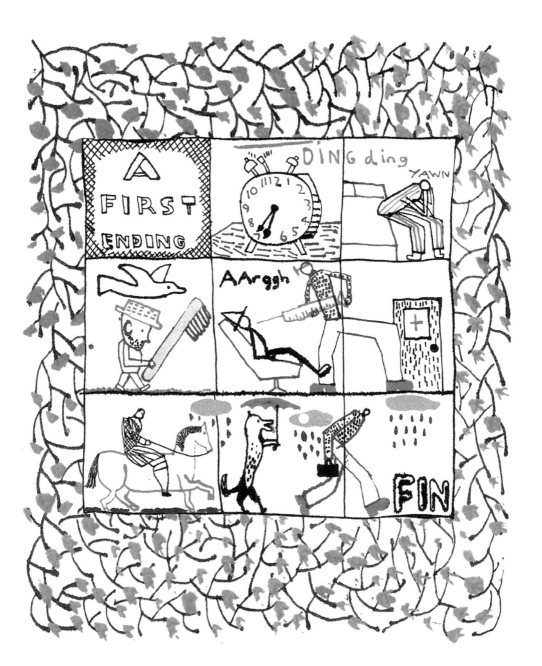

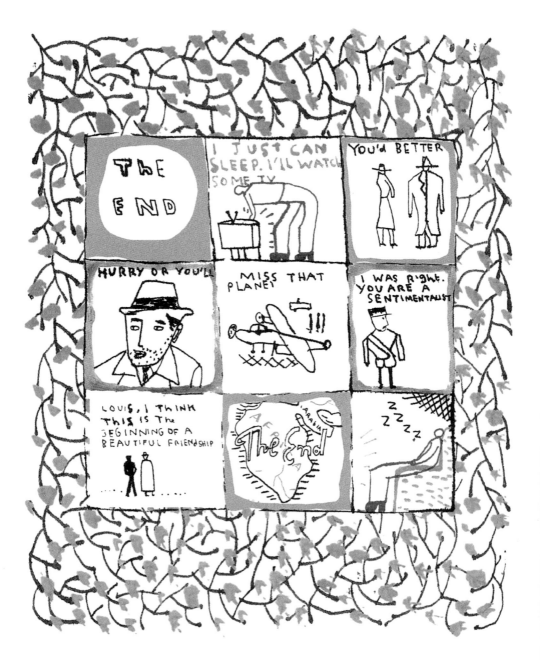

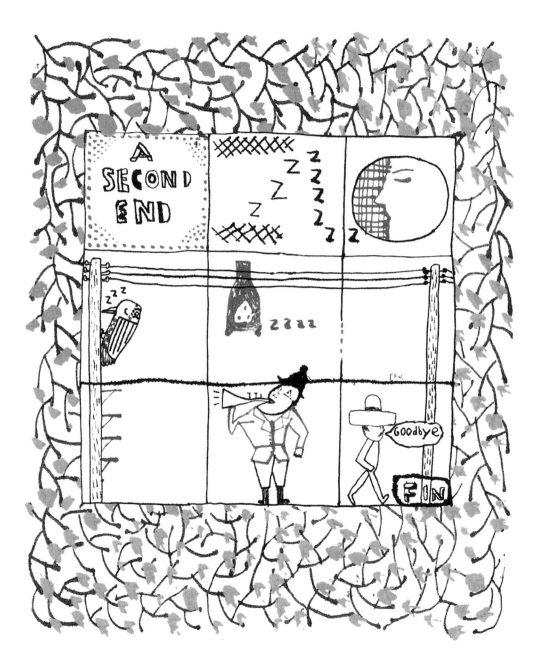

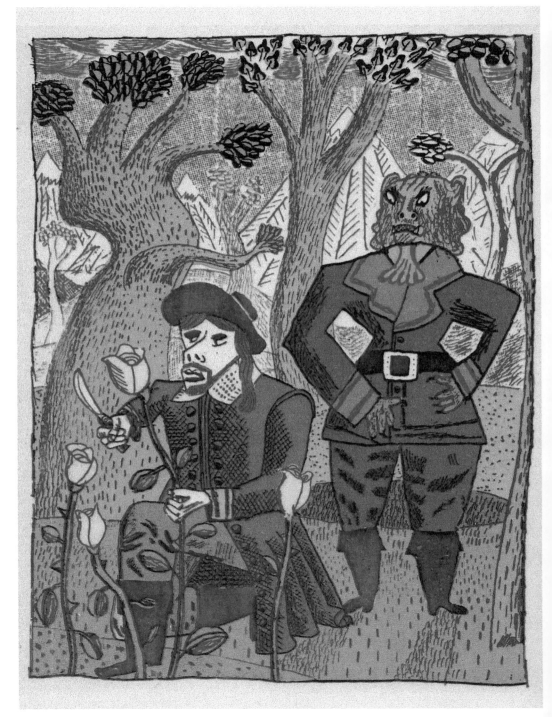

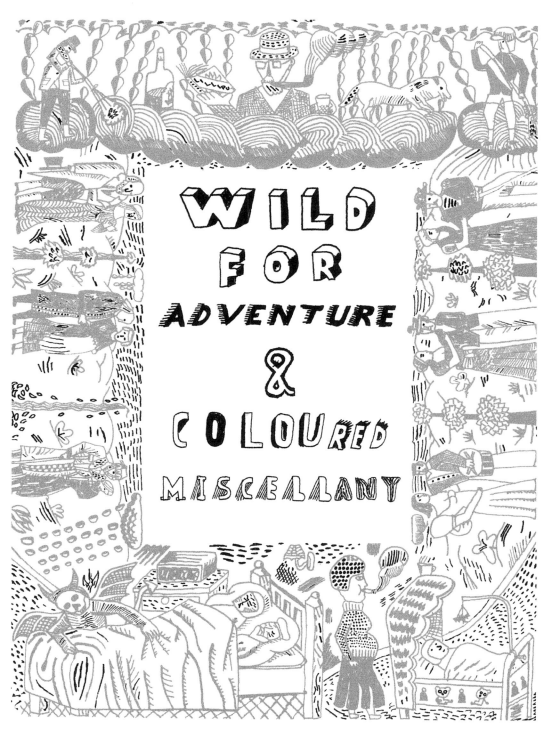

WILD
FOR
ADVENTURE
&
COLOURED
MISCELLANY

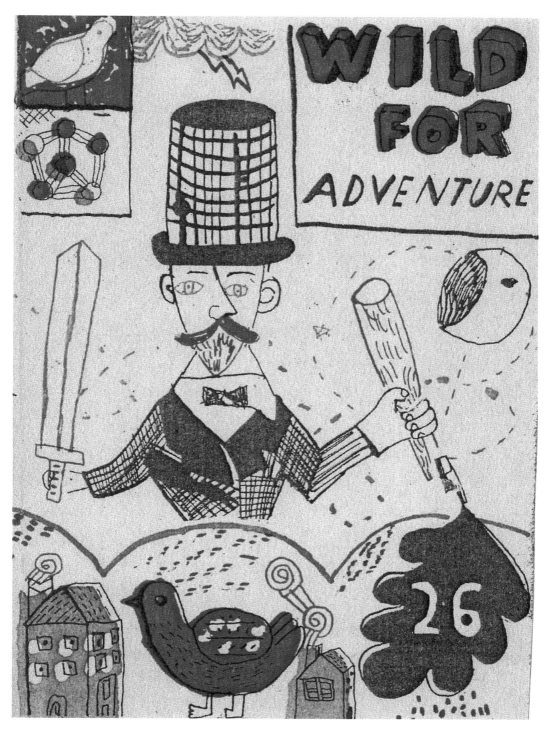

WILD FOR

ADVENTURE

26

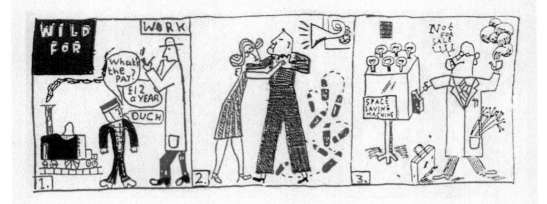

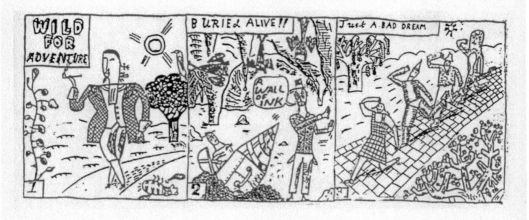

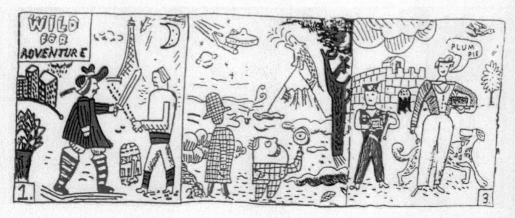

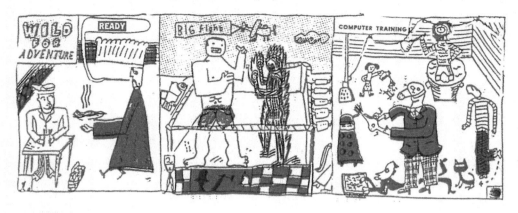

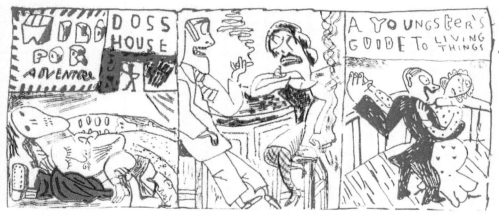

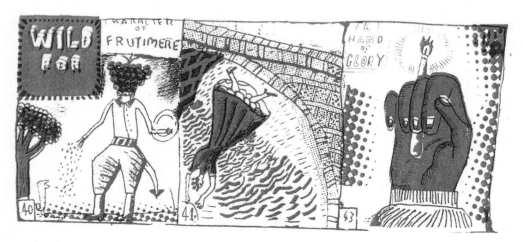

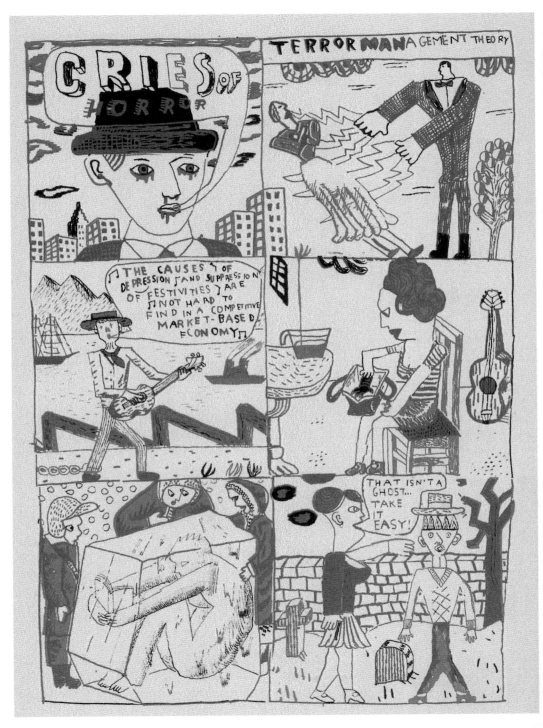

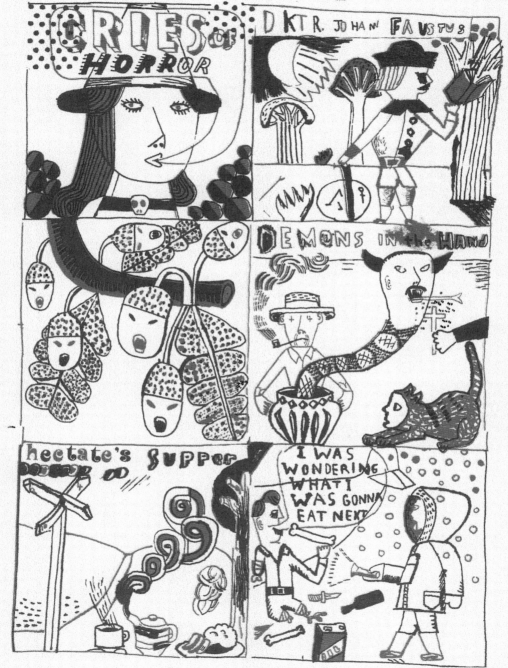

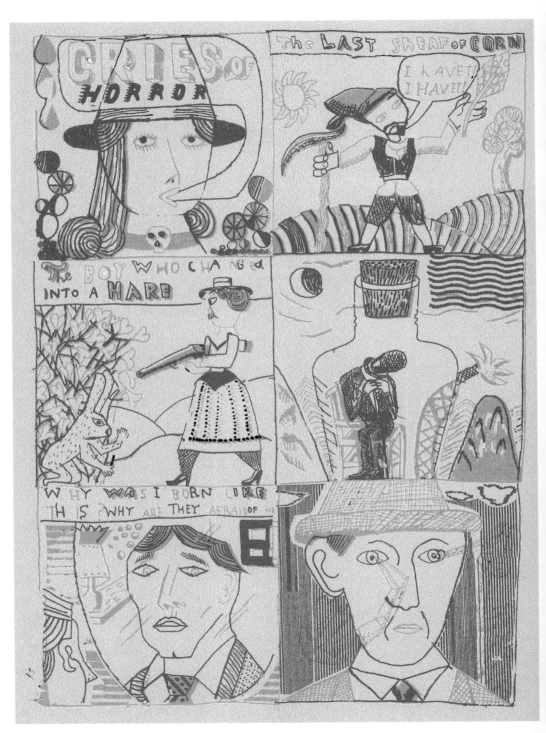

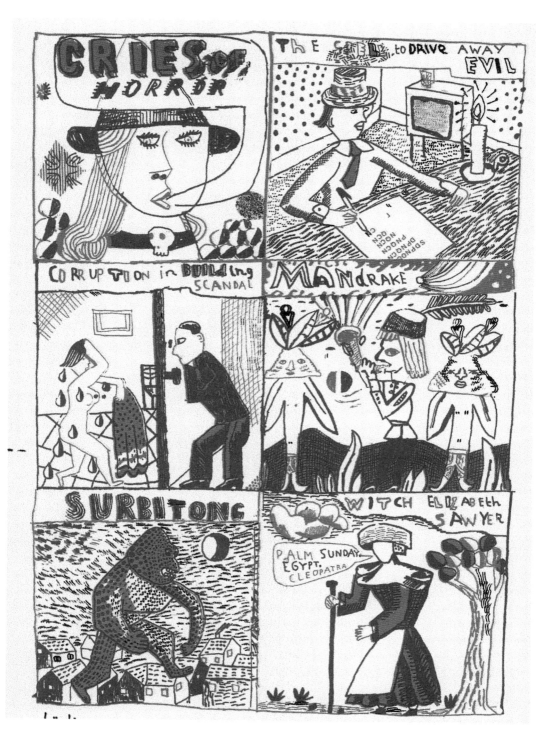

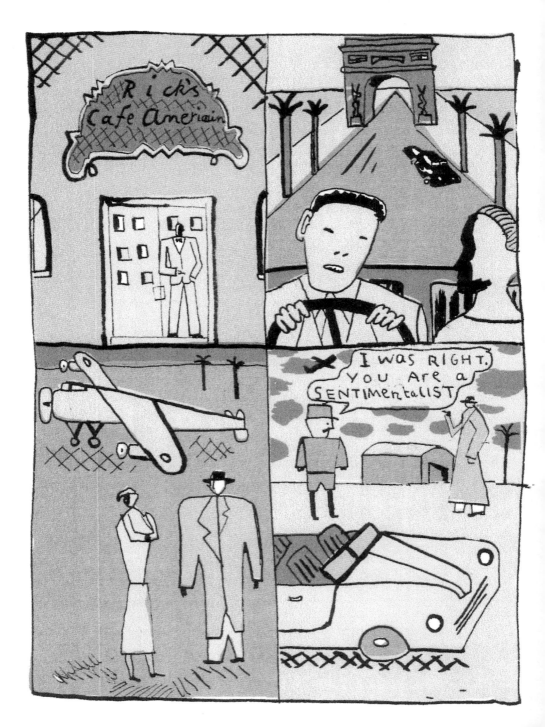

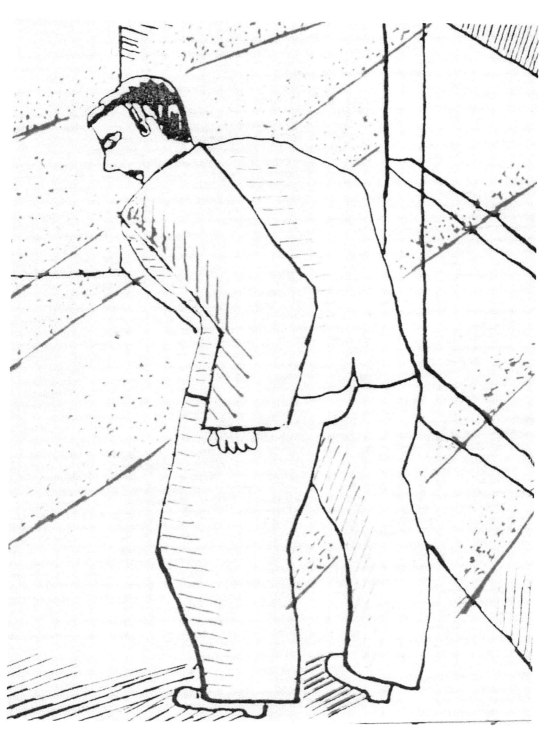

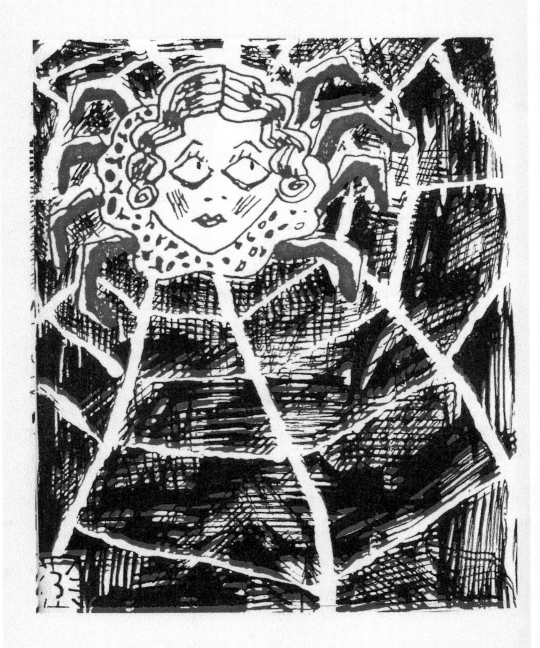

THE VANDORE LEGACY

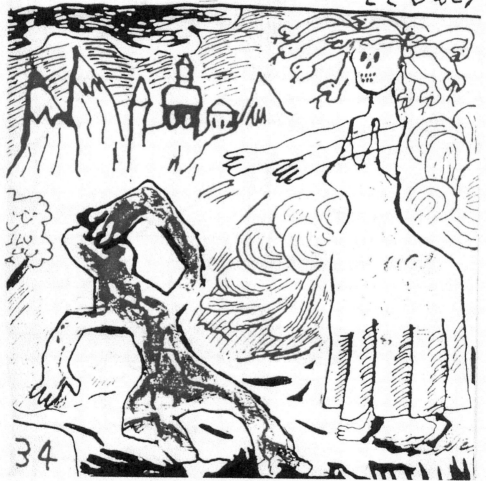

34

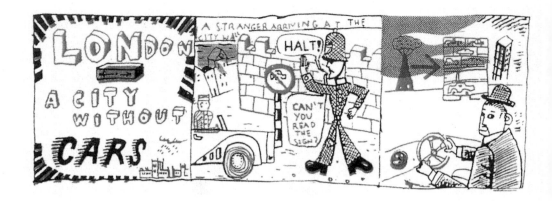

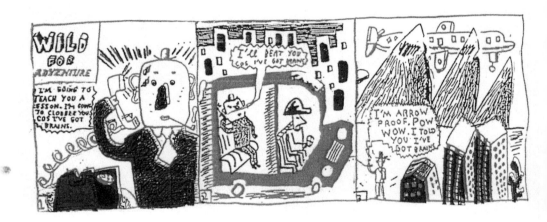

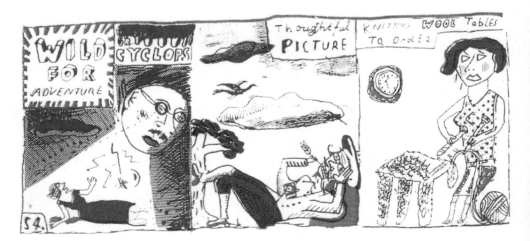

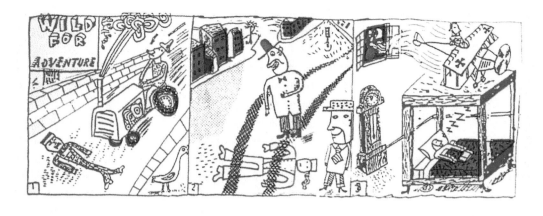

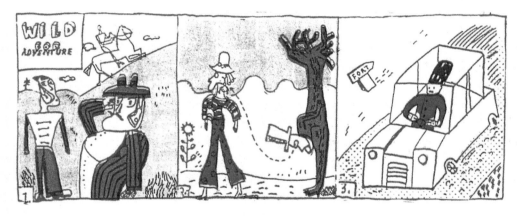

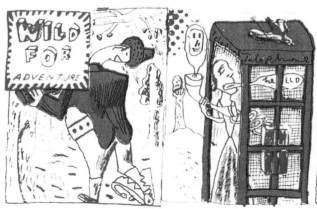
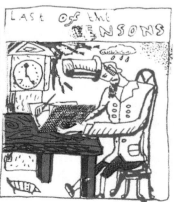

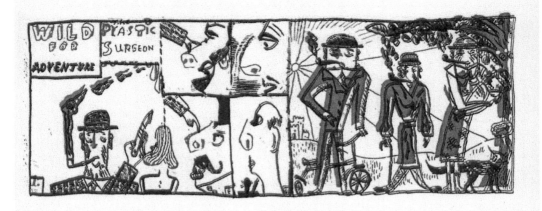

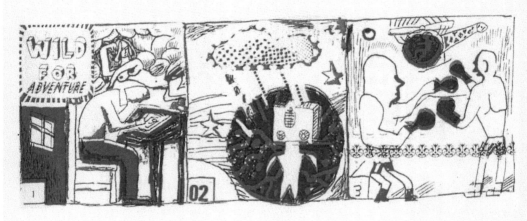

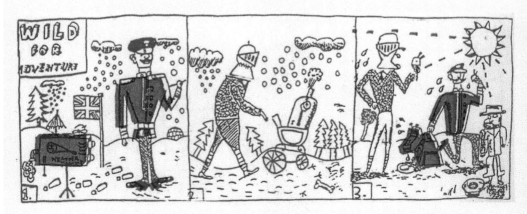

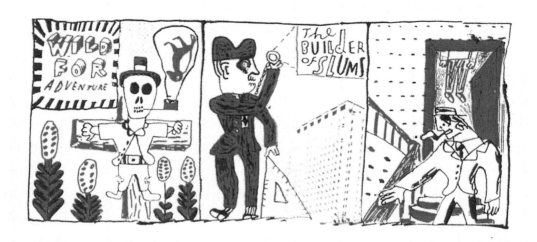

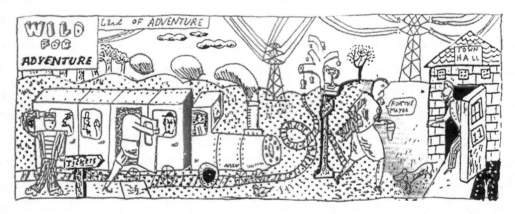

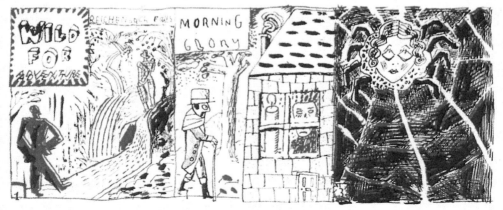

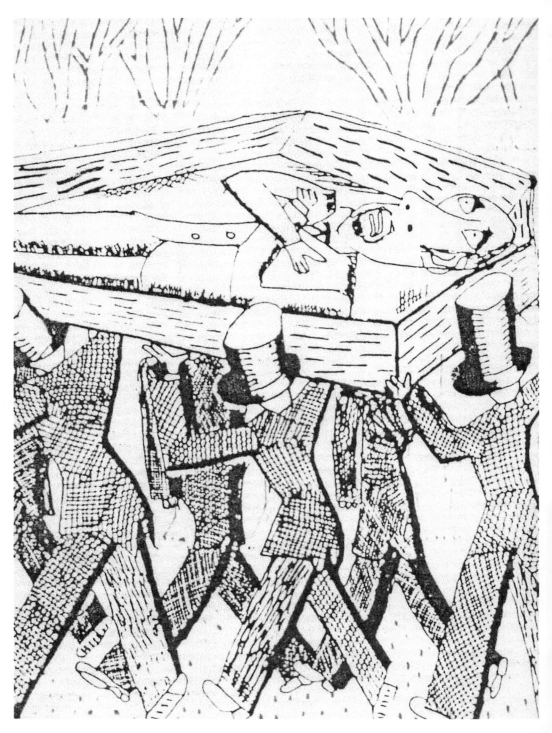

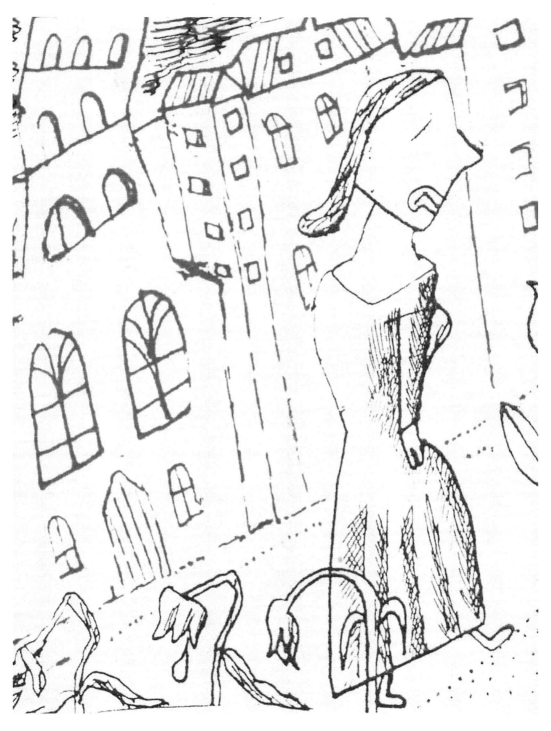

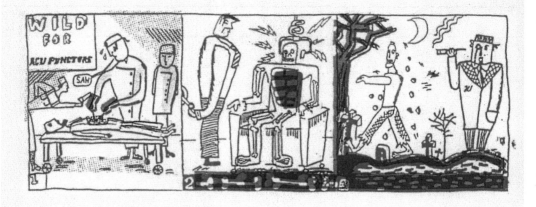

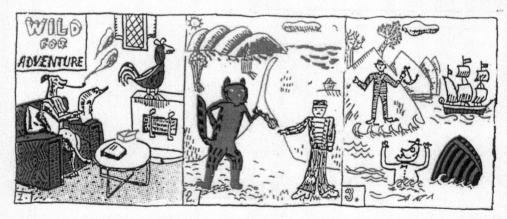

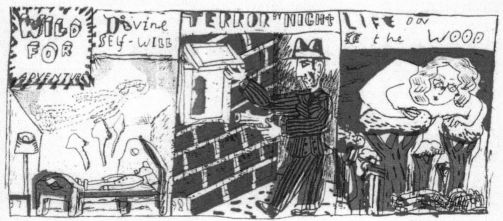

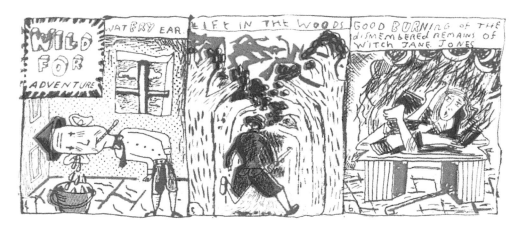

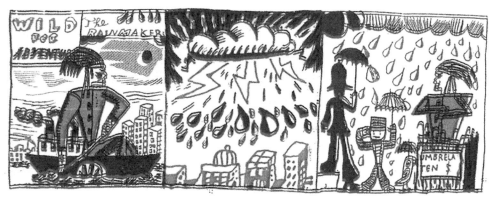

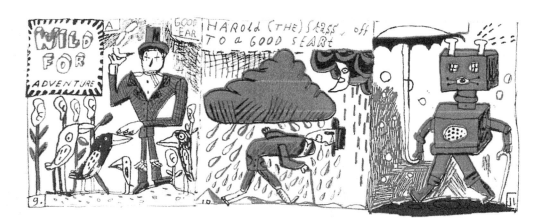

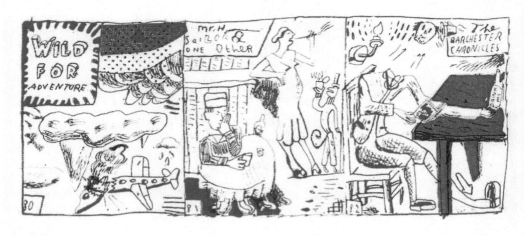

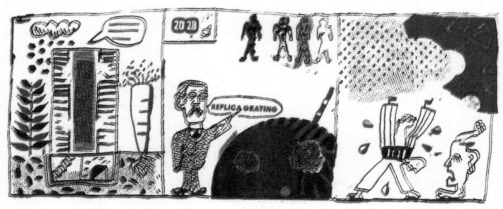

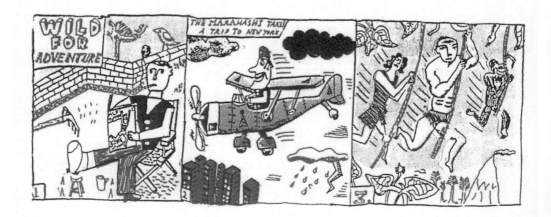

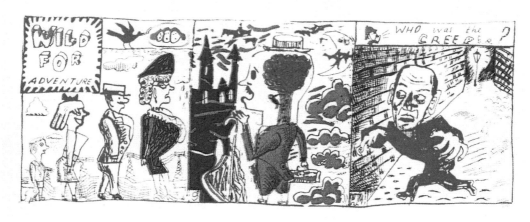

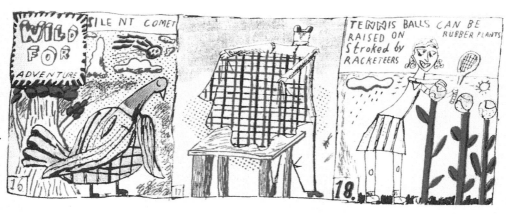

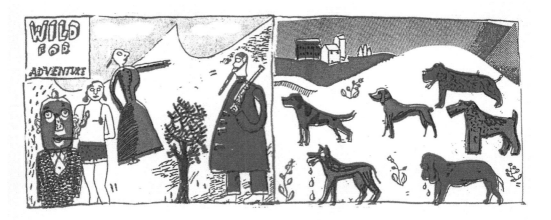

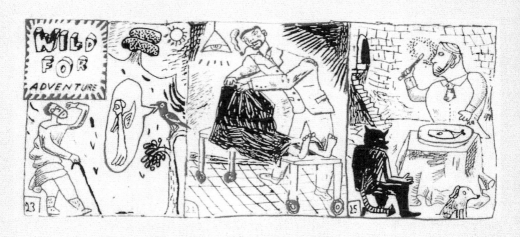

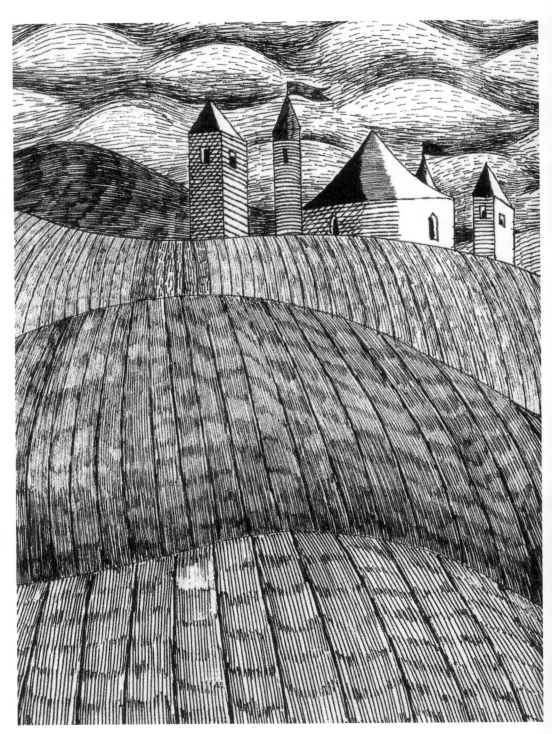

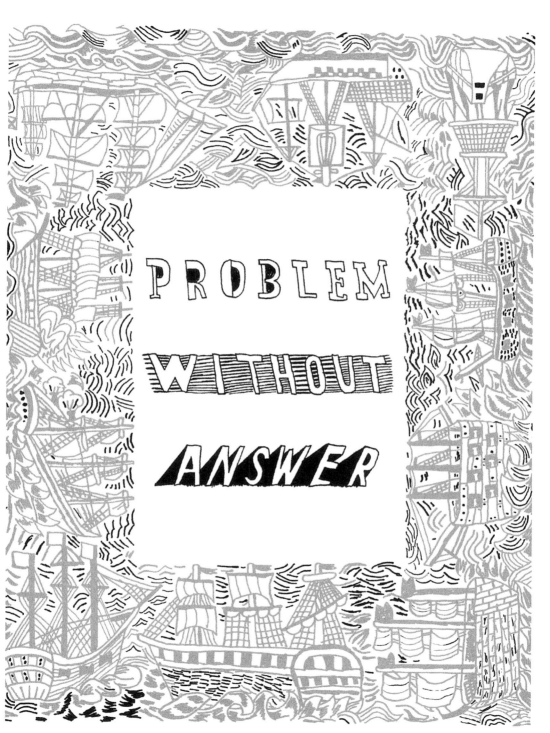

Feb
2002

PROBLEM
WITHOUT
ANSWER

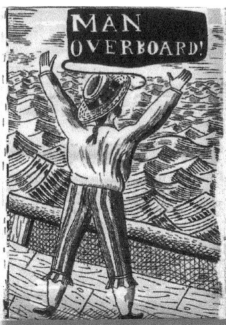

MAN
OVERBOARD!

Cut off
my
head
and I
shall still
be
found

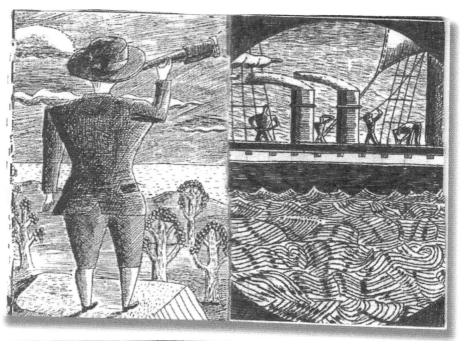

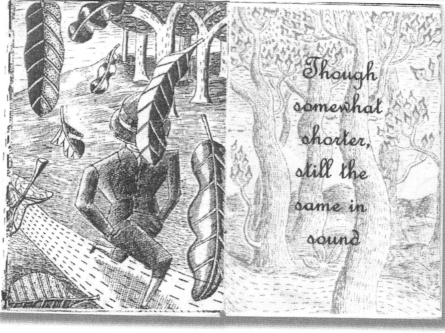

Though somewhat shorter, still the same in sound

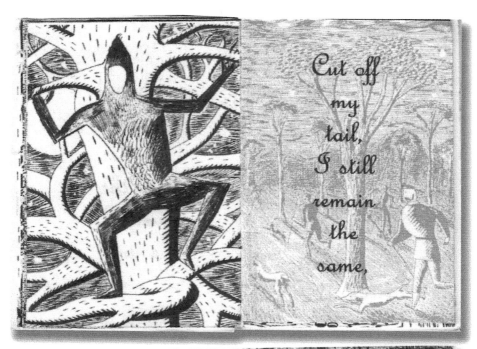

Cut off
my
tail,
I still
remain
the
same,

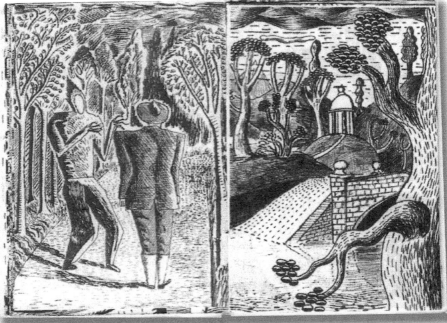

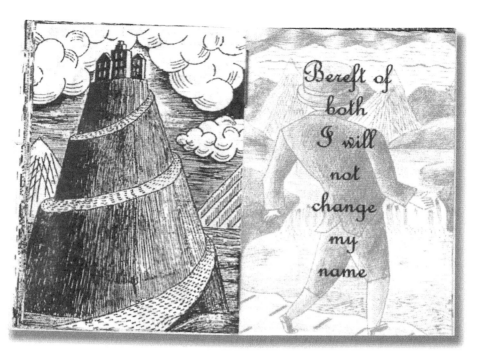

Bereft of
both
I will
not
change
my
name

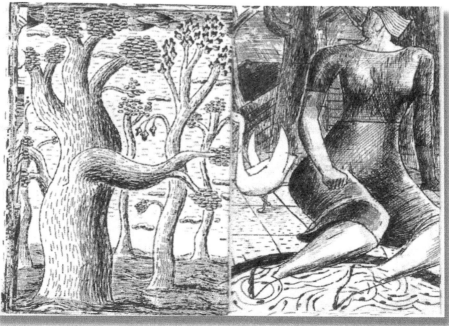

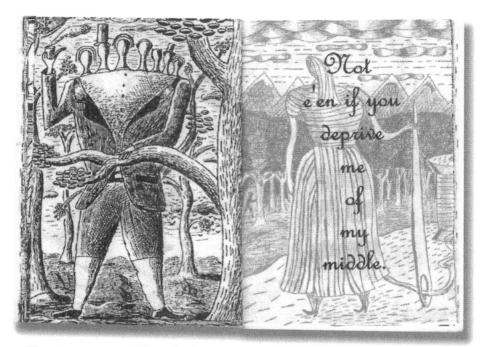

Not
'e en if you
deprive
me
of
my
middle.

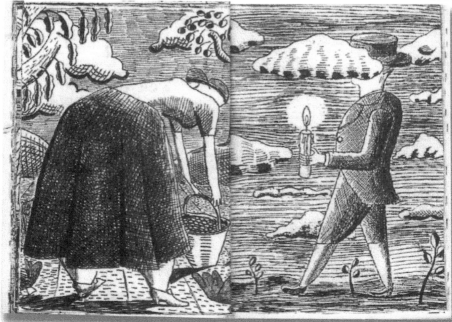

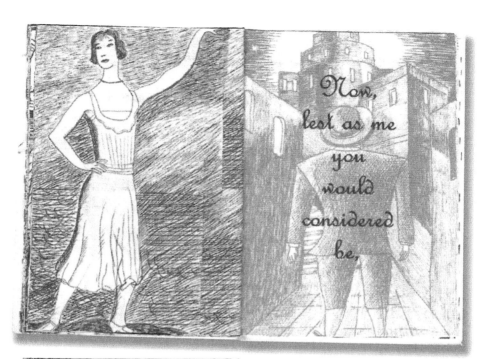

Now,
lest as me
you
would
considered
be,

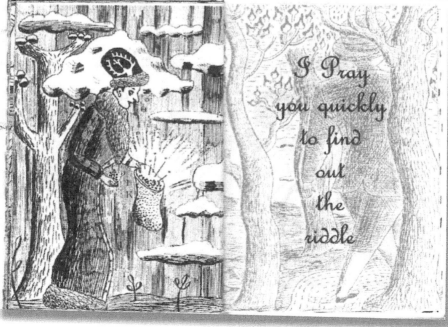

I Pray
you quickly
to find
out
the
riddle

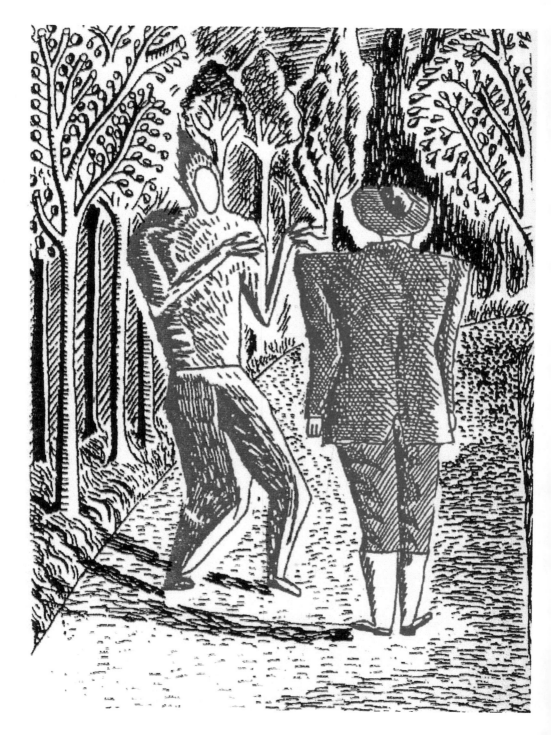

NETTLESOME //

GAUss

RIDDLES

NETTLE SOME

BY

John BRoadley

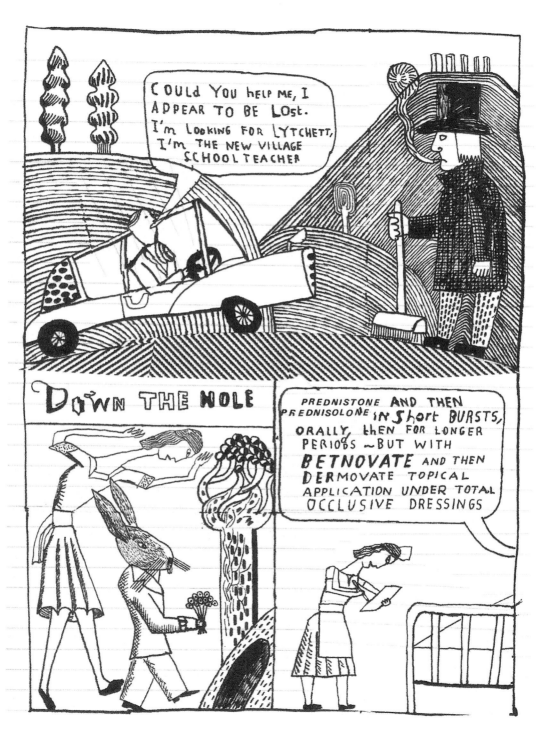

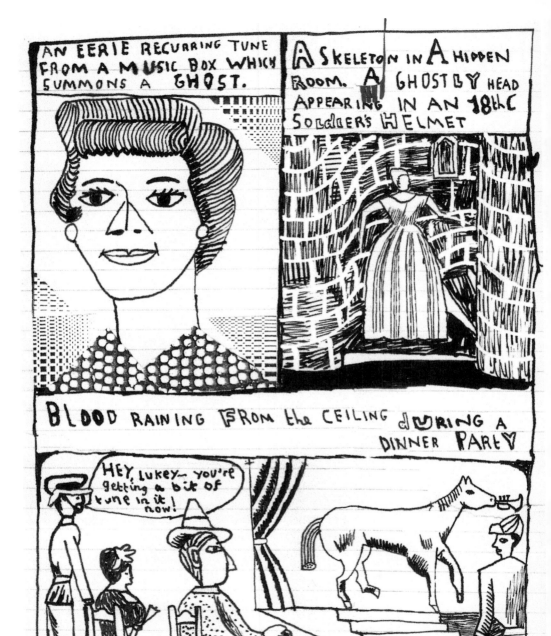

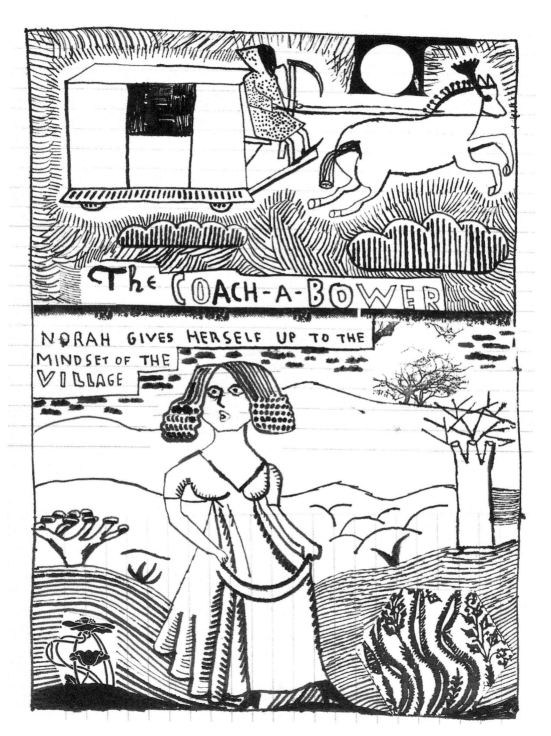

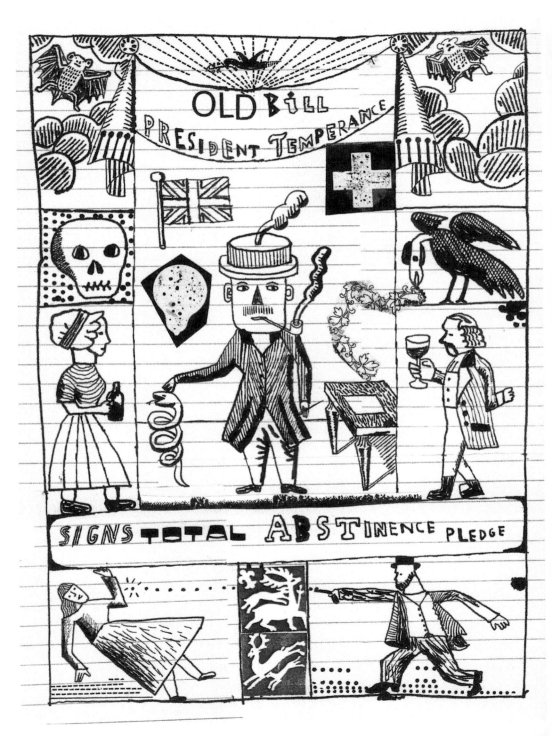

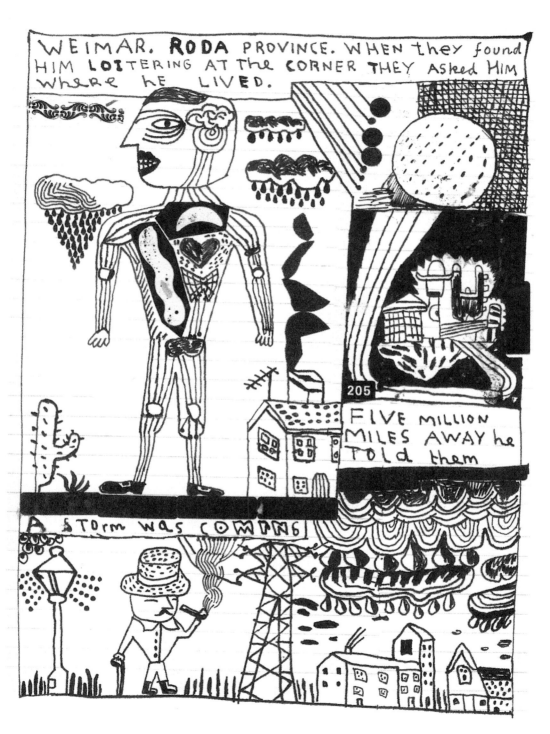

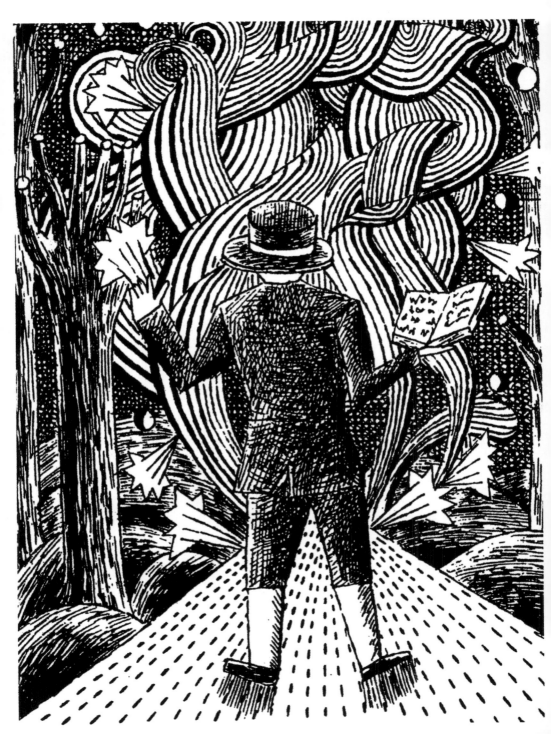

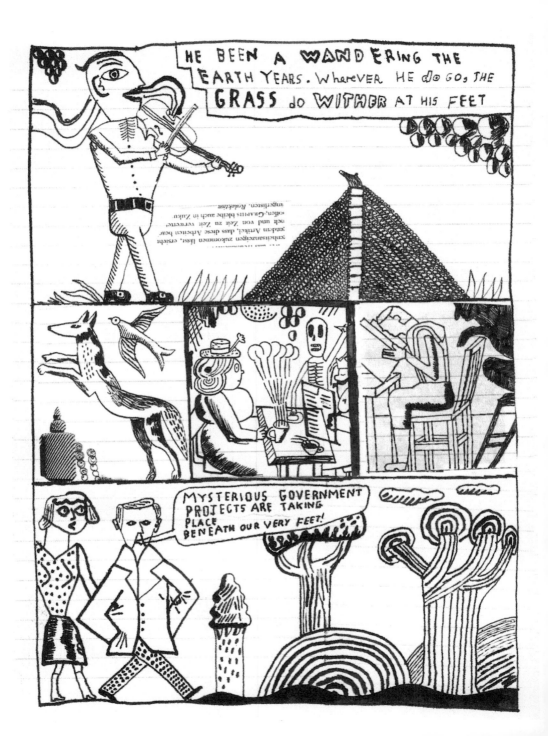

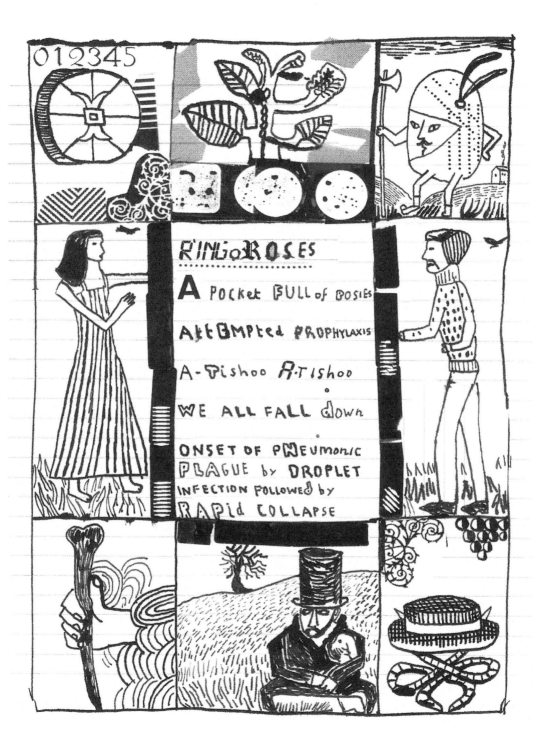

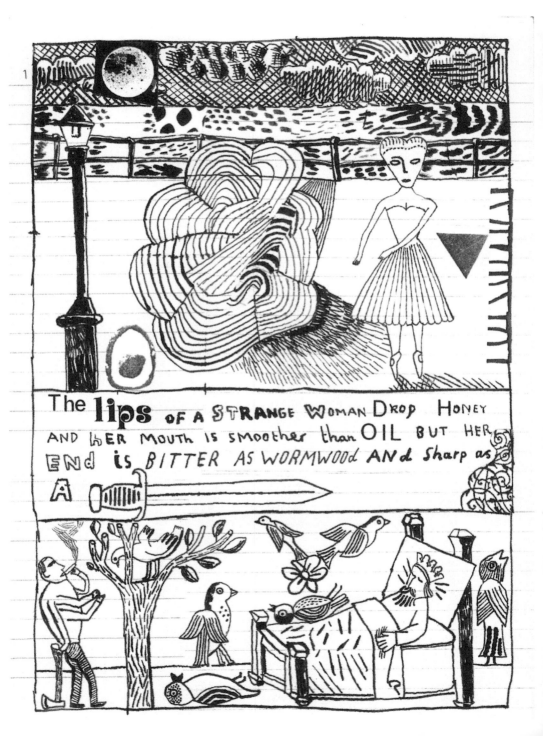

The **lips** OF A STRANGE WOMAN DROP HONEY AND hER MOUTH IS smoother than OIL BUT HER ENd **is** BITTER AS WORMWOOD ANd Sharp as A

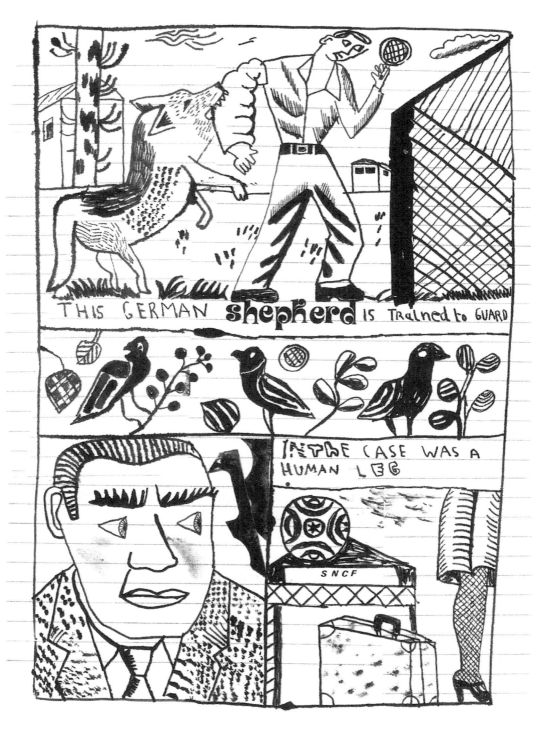

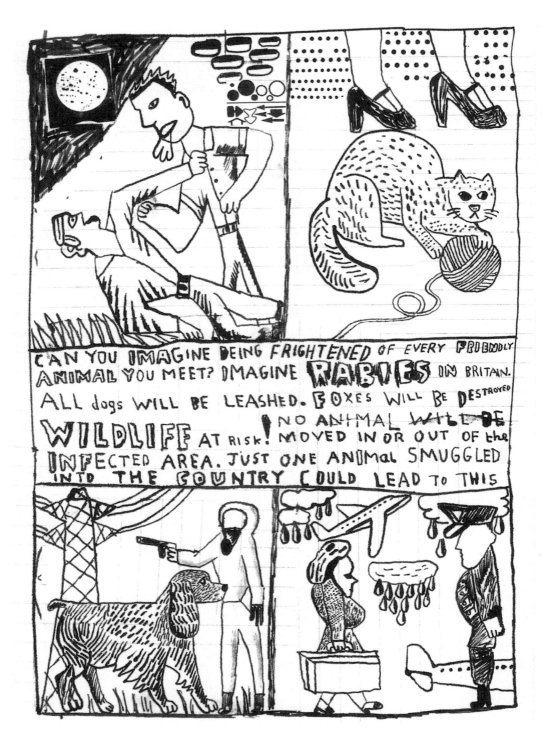

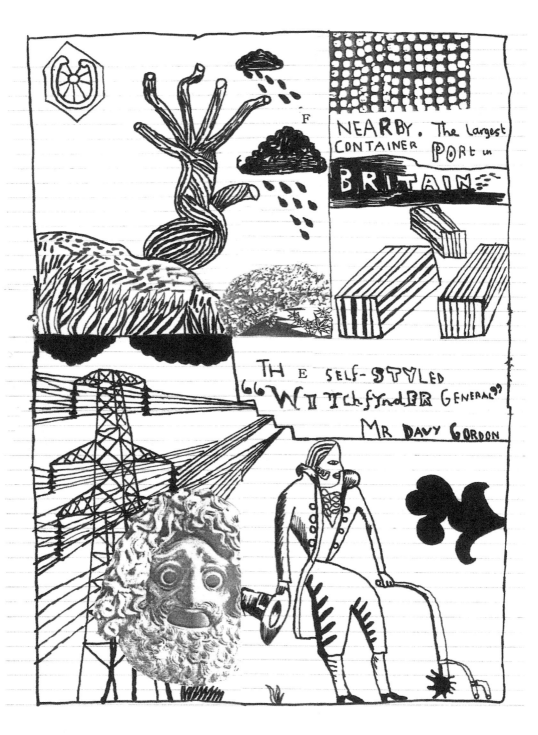

F

NEARBY, The Largest
CONTAINER PORT in
BRITAIN

THE SELF-STYLED
"WIITchfyndER GENERAL"
MR DAVY GORDON

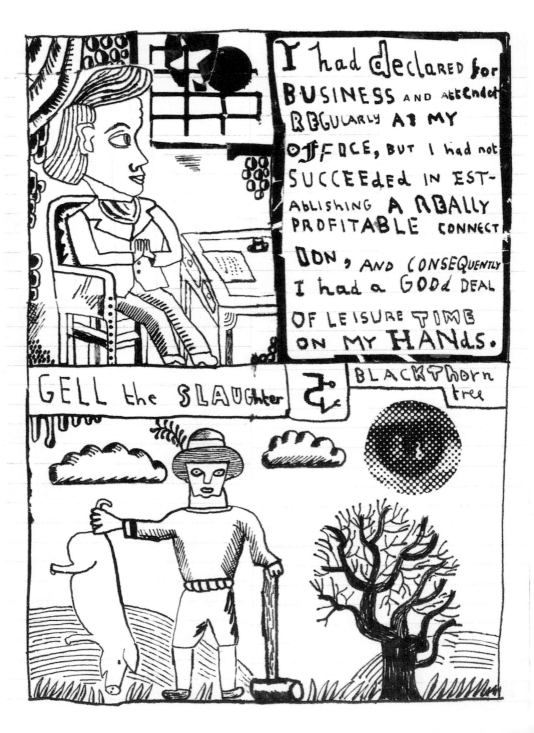

I had declared for BUSINESS AND attEndet REGULARLY AT MY OFFICE, BUT I had not SUCCEEded IN ESTAblishing A REAlly PROFITABLE CONNECTION, AND CONSEQUENtly I had a GOOd DEAL OF LEISURE TIME ON MY HANdS.

GELL the SLAUGhter

BLACKTHORN tree

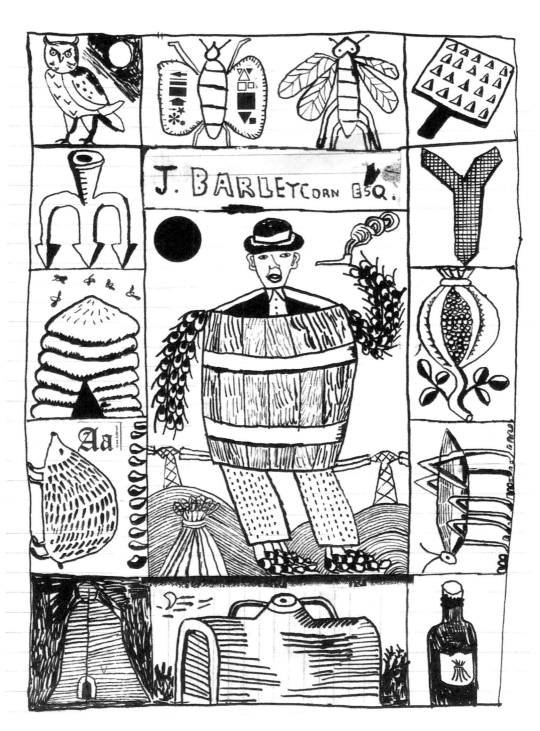

J. BARLEYCORN ESQ.

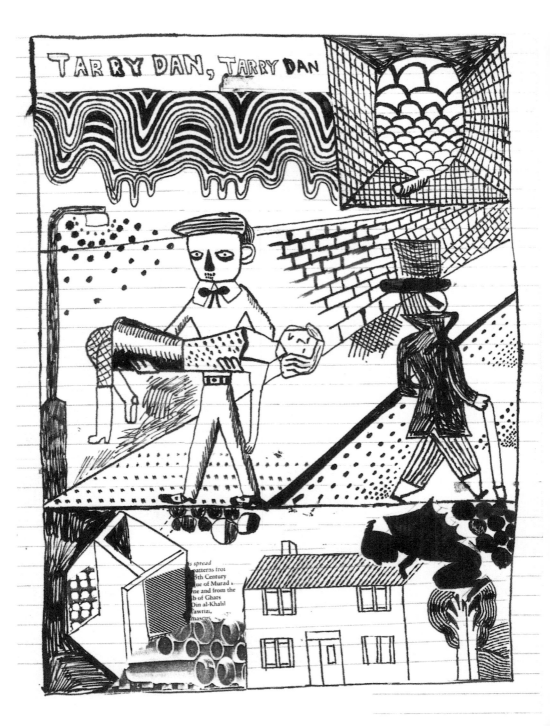

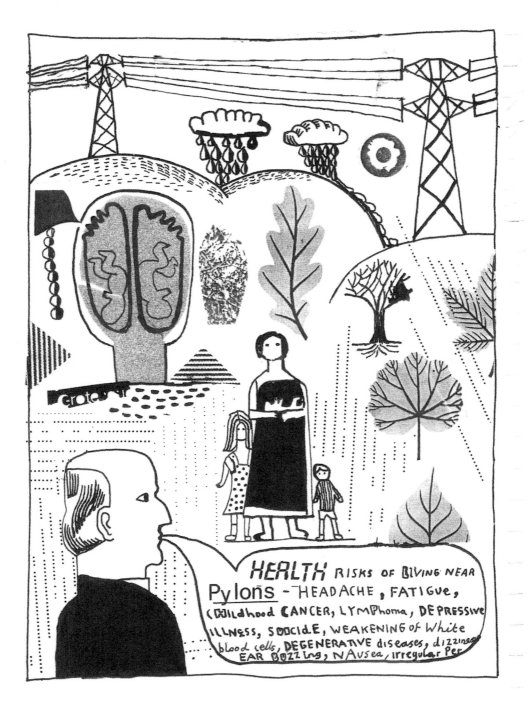

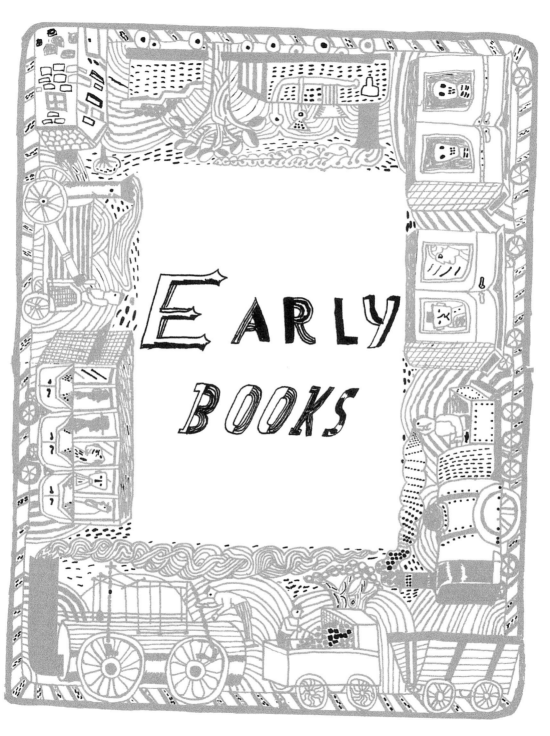

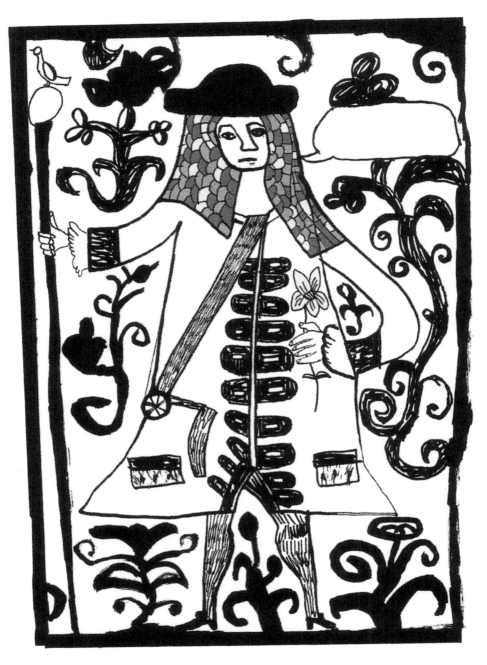

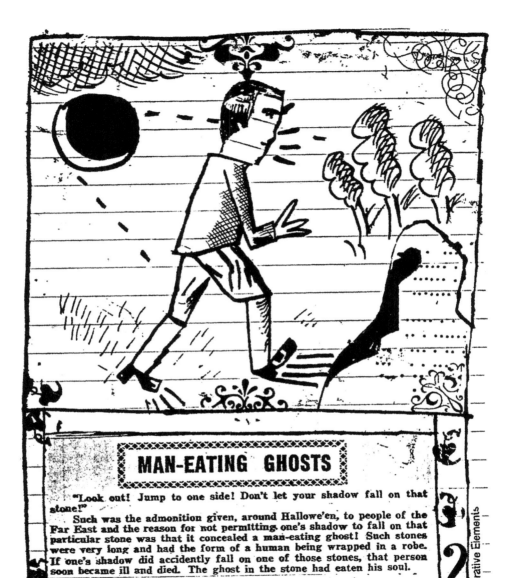

MAN-EATING GHOSTS

"Look out! Jump to one side! Don't let your shadow fall on that stone!"

Such was the admonition given, around Hallowe'en, to people of the Far East and the reason for not permitting one's shadow to fall on that particular stone was that it concealed a man-eating ghost! Such stones were very long and had the form of a human being wrapped in a robe. If one's shadow did accidently fall on one of those stones, that person soon became ill and died. The ghost in the stone had eaten his soul.

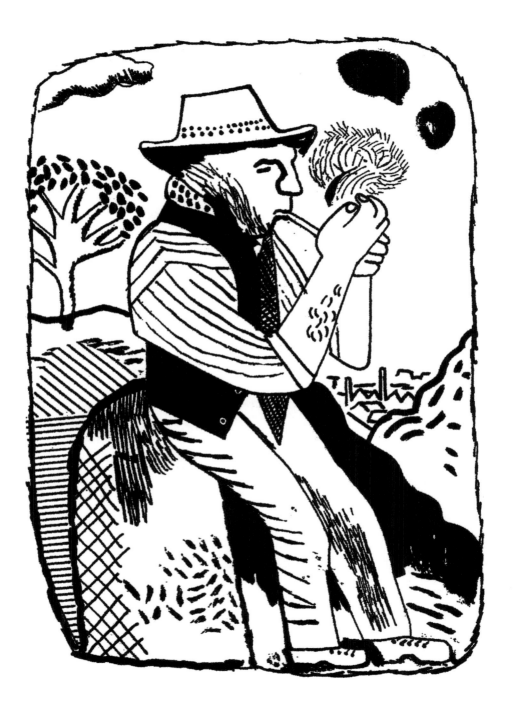

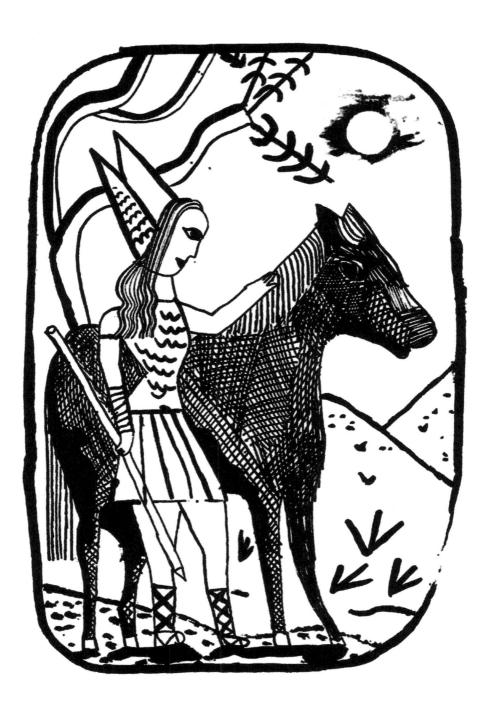

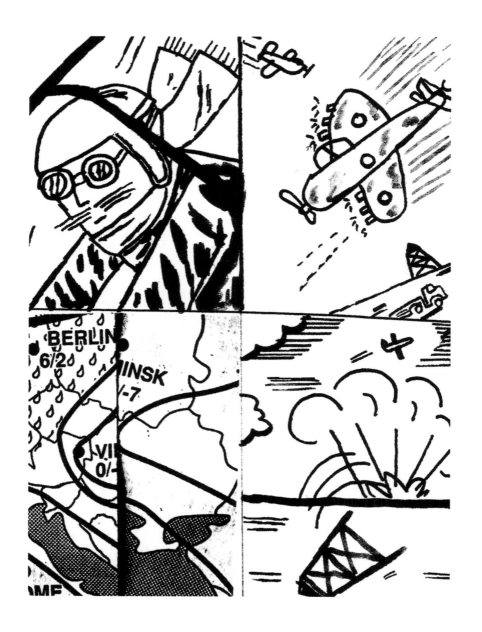

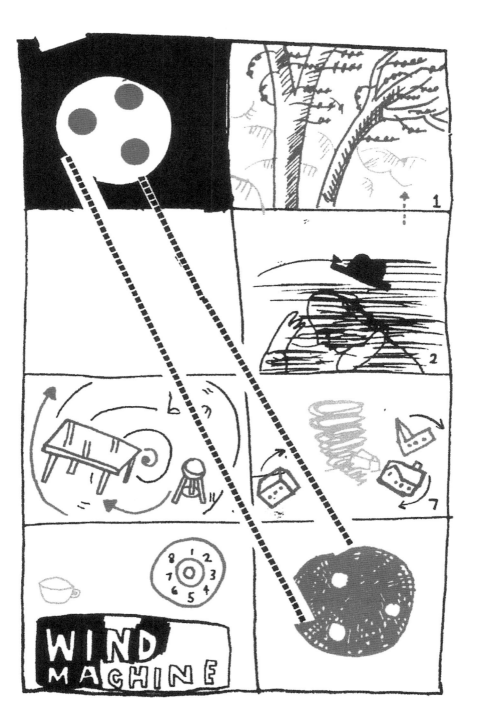

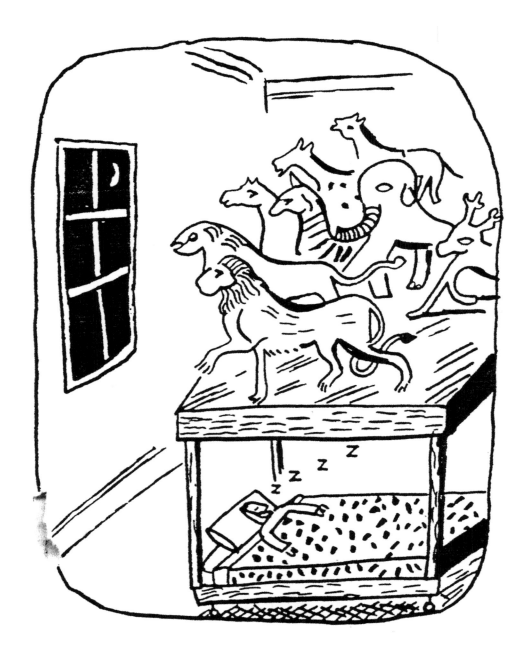

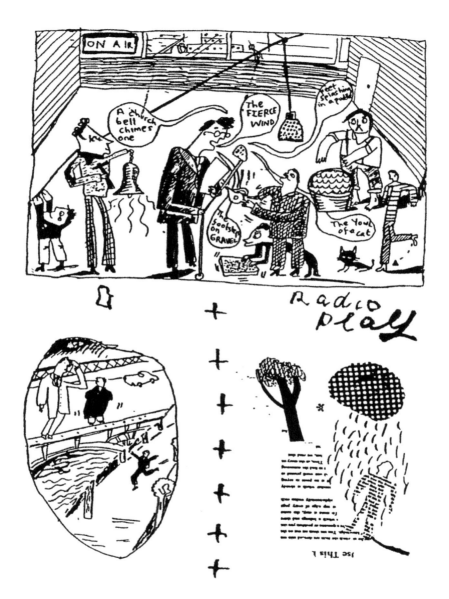

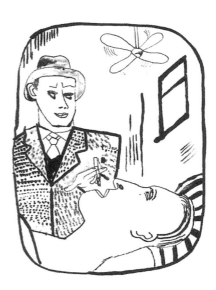

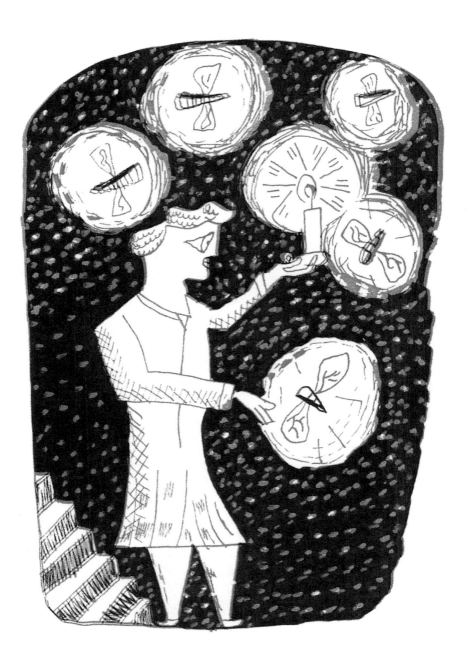

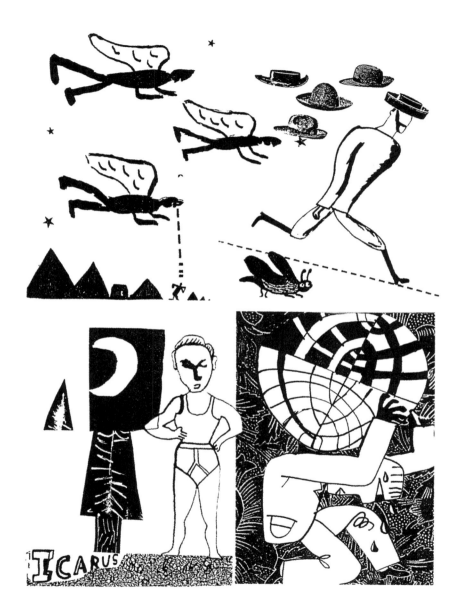

ICARUS

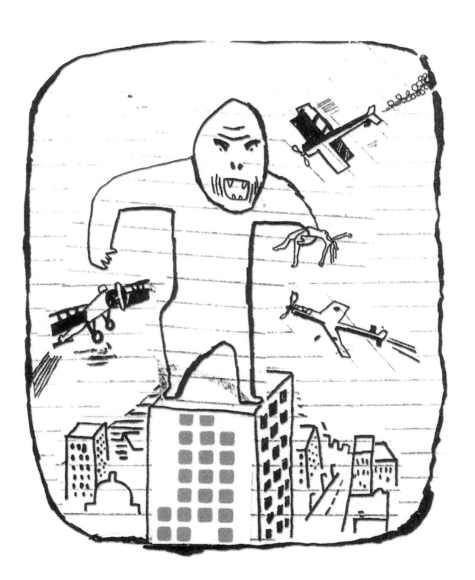

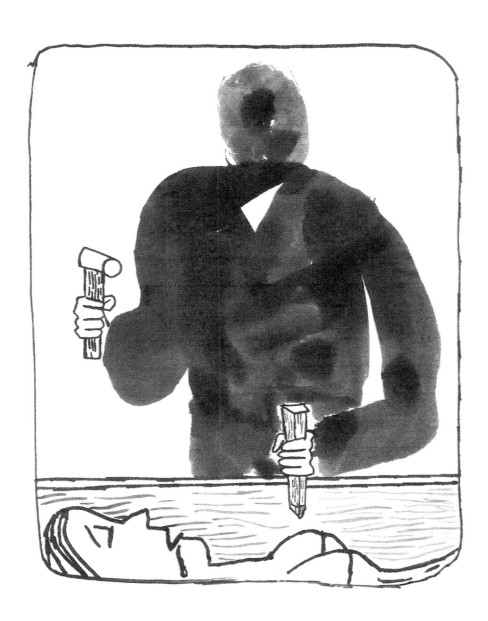

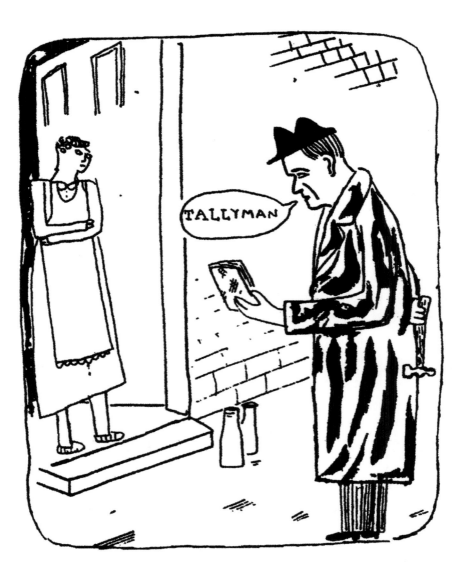

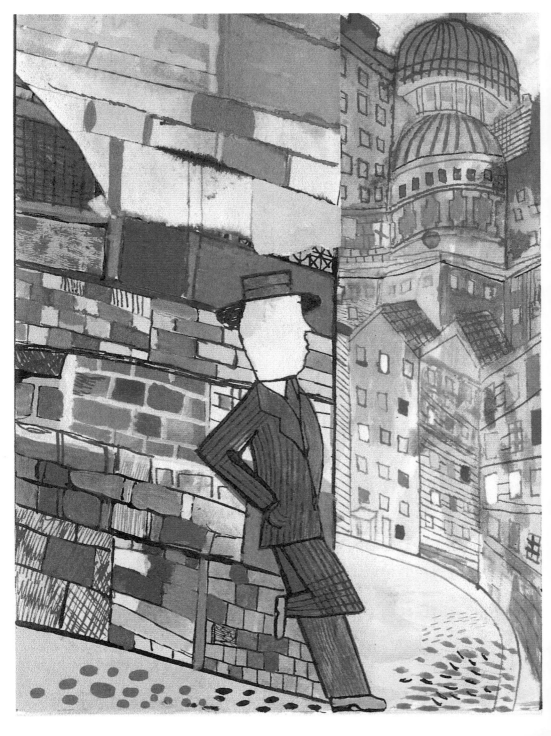

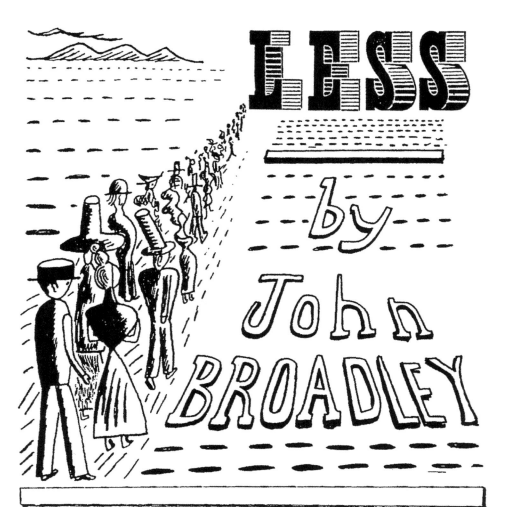

MORE in LESS

by John Broadley

DECEMBER 1999

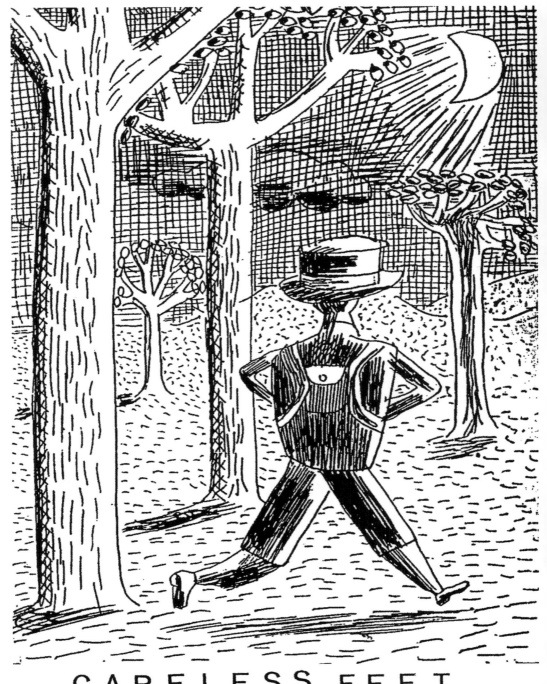

CARELESS FEET

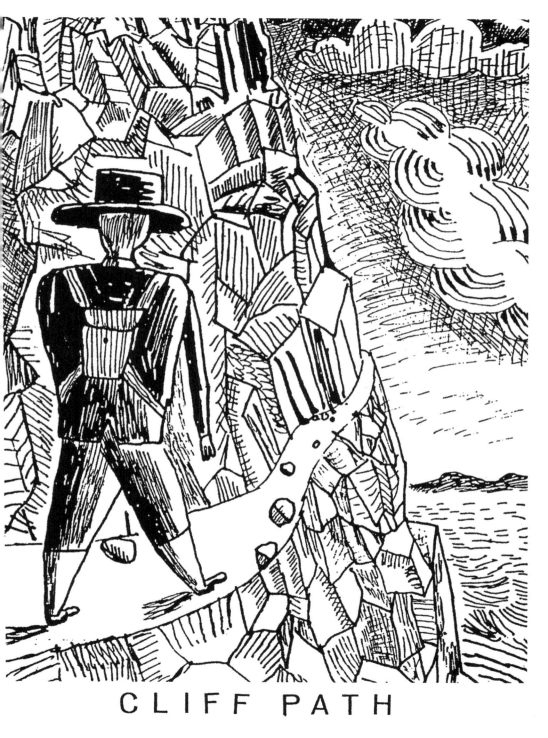

CLIFF PATH

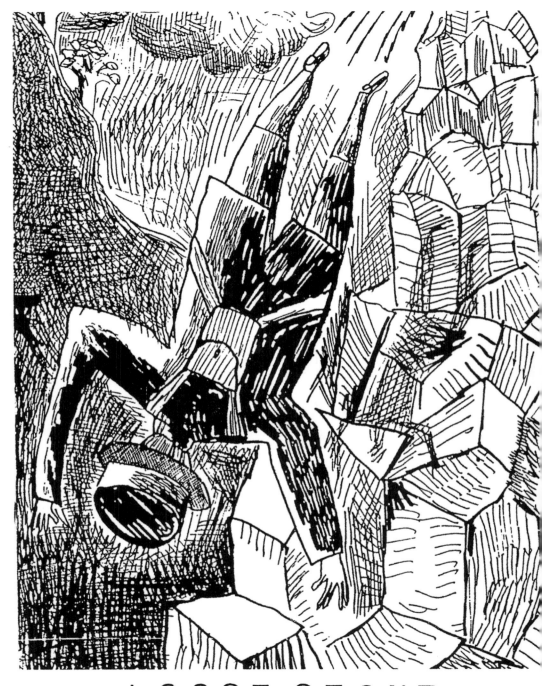

LOOSE STONE

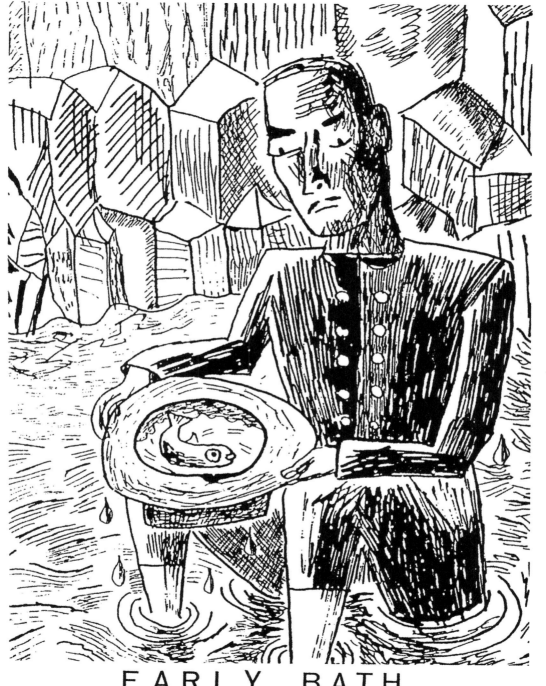

EARLY BATH

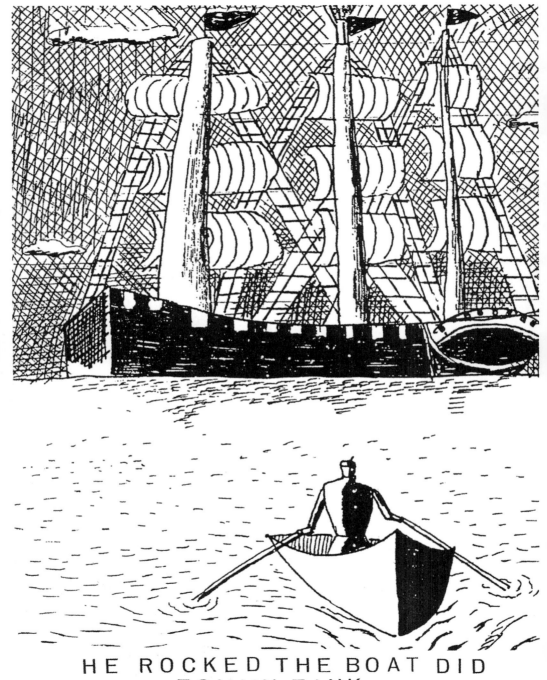

HE ROCKED THE BOAT DID
TOMMY TANK

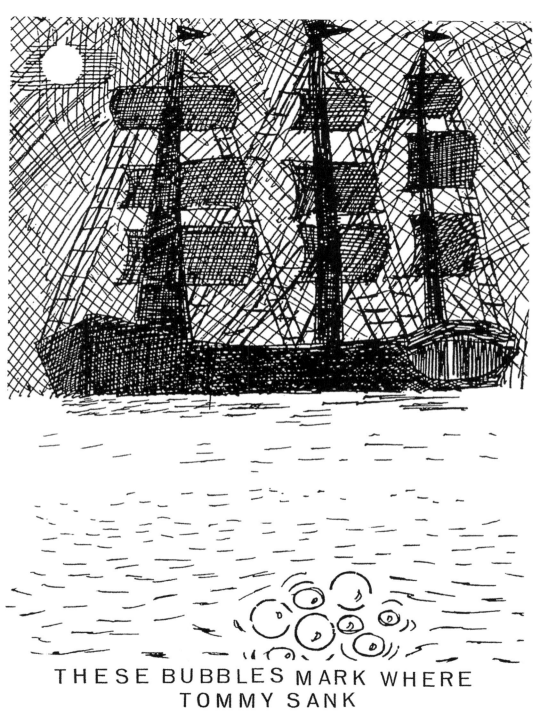

THESE BUBBLES MARK WHERE
TOMMY SANK

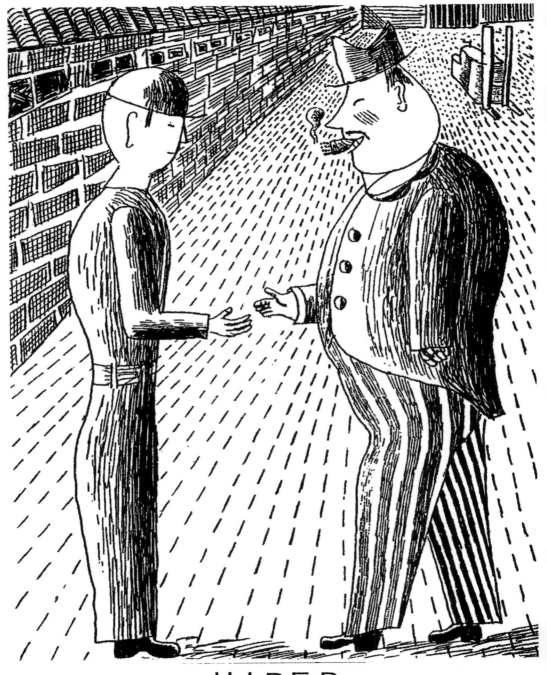

HIRED

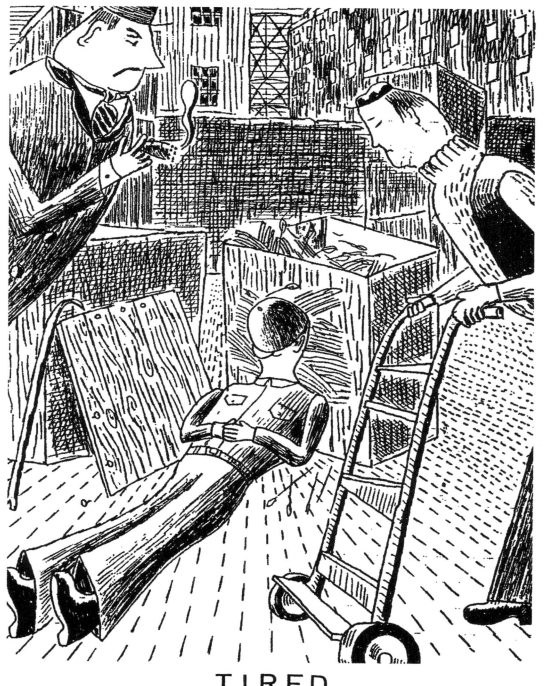

TIRED

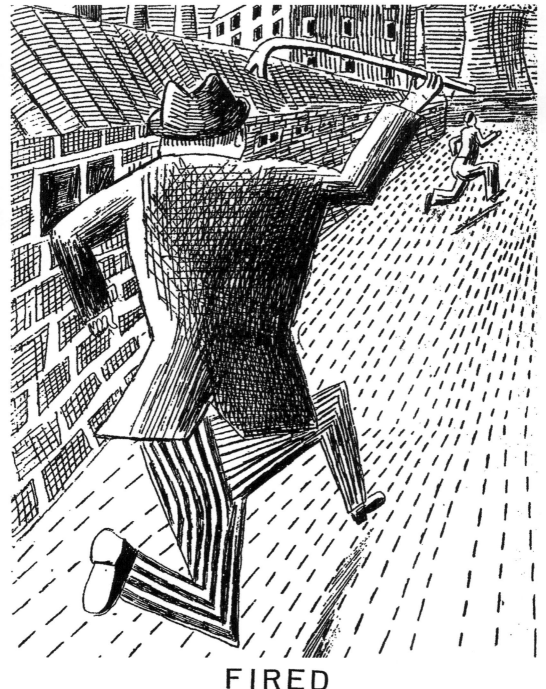

FIRED

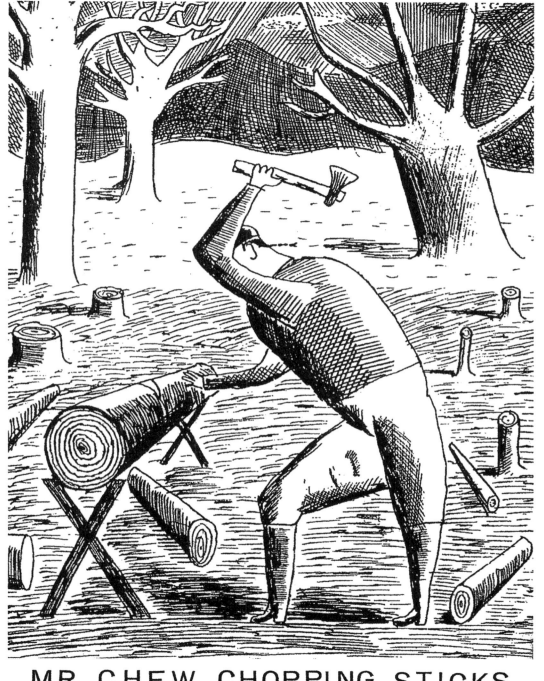

MR CHEW CHOPPING STICKS

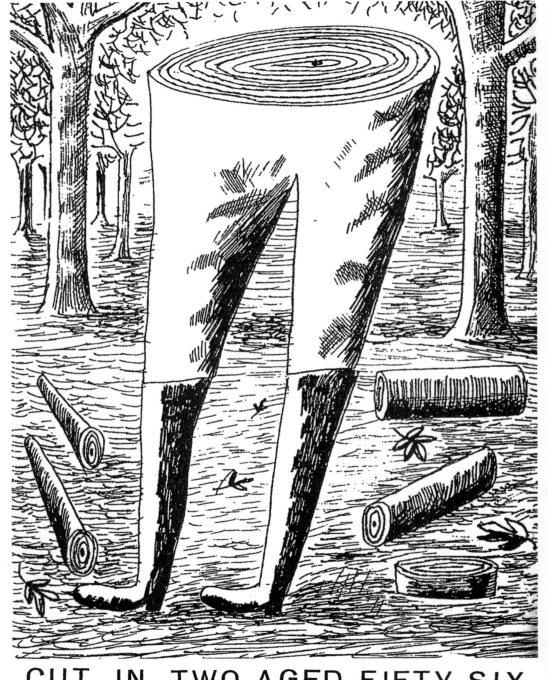

CUT IN TWO AGED FIFTY SIX

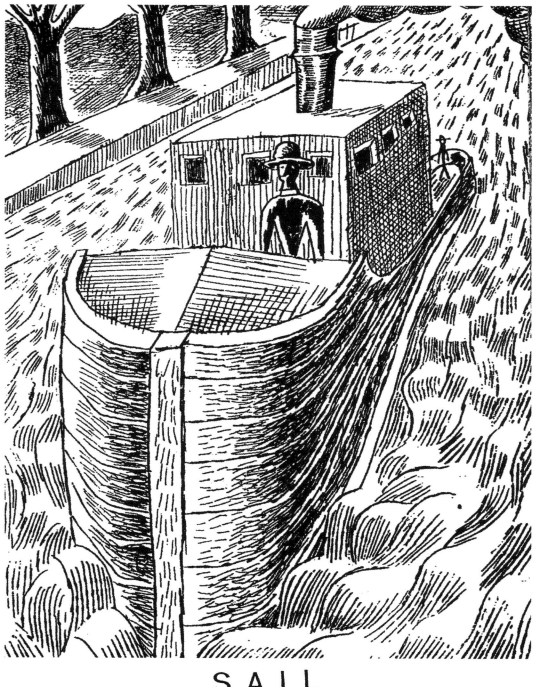

SAIL

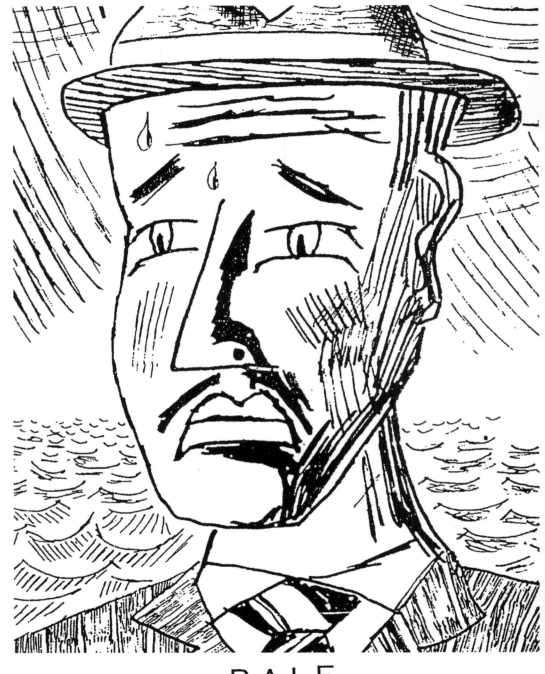

PALE

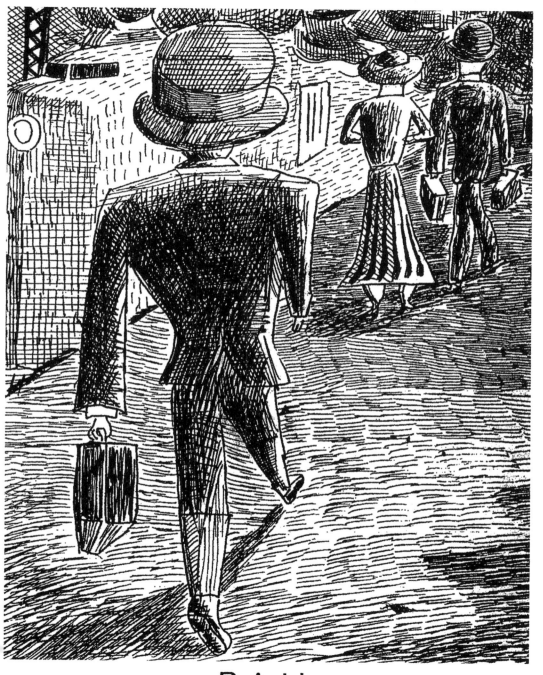

RAIL

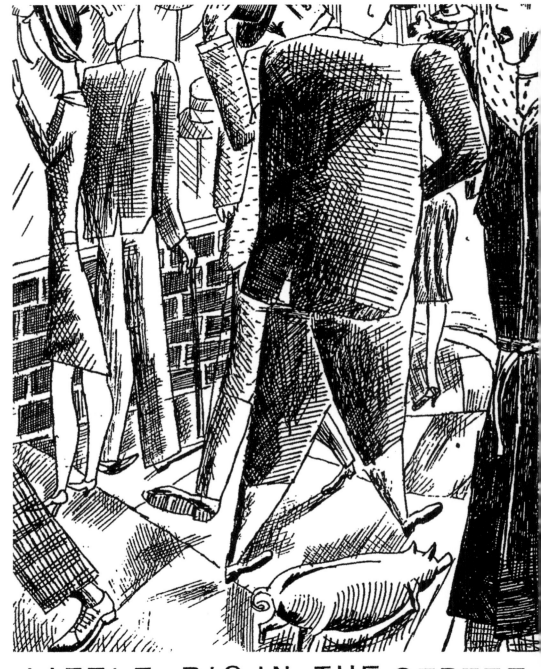

LITTLE PIG IN THE STREET

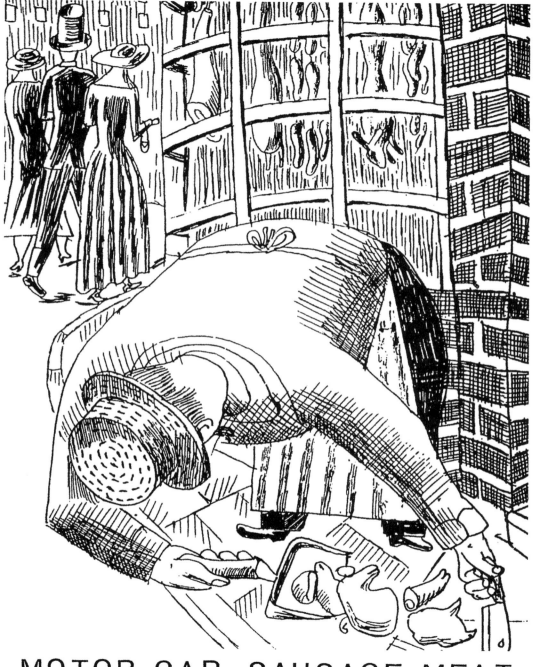

MOTOR CAR SAUSAGE MEAT

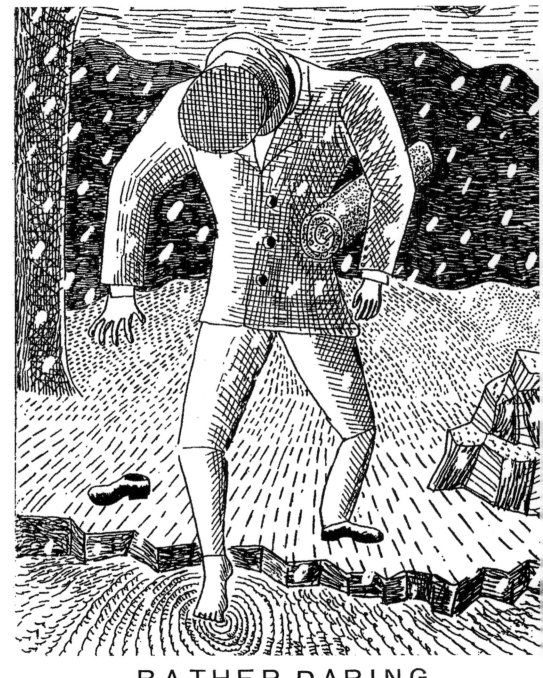

BATHER DARING

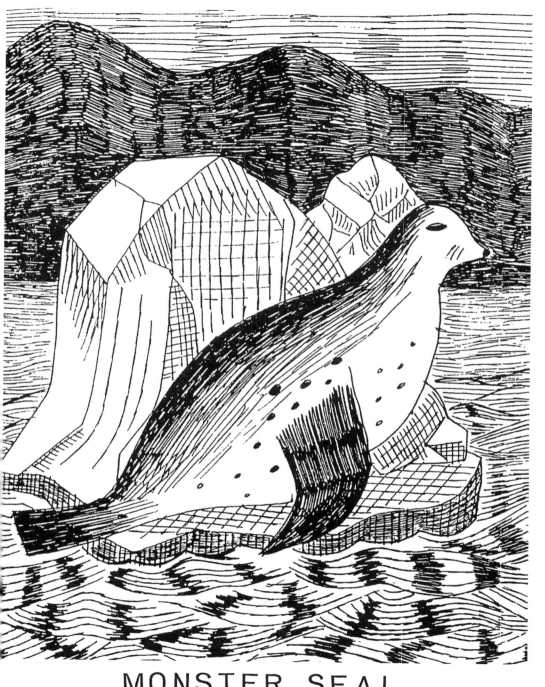

MONSTER SEAL

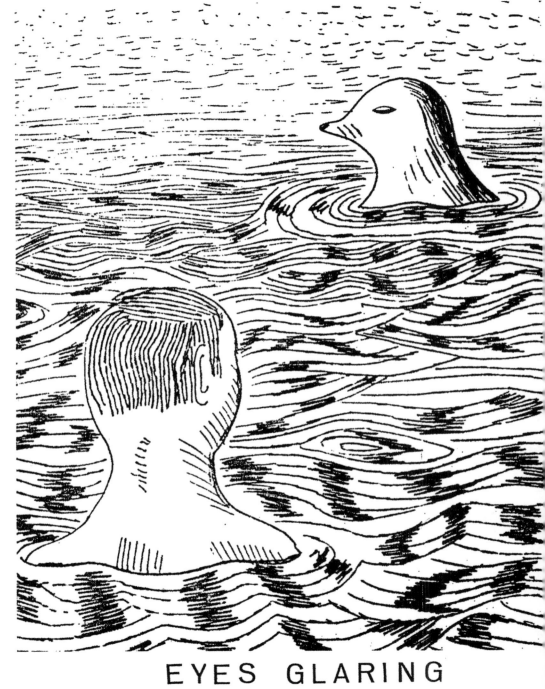

EYES GLARING

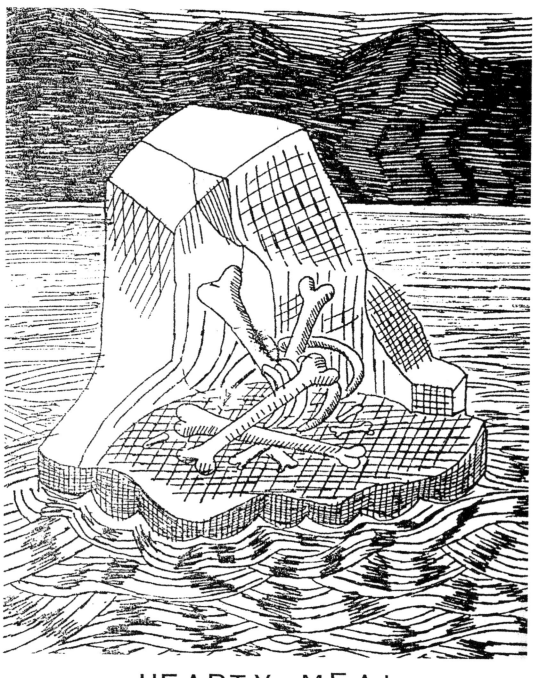

HEARTY MEAL

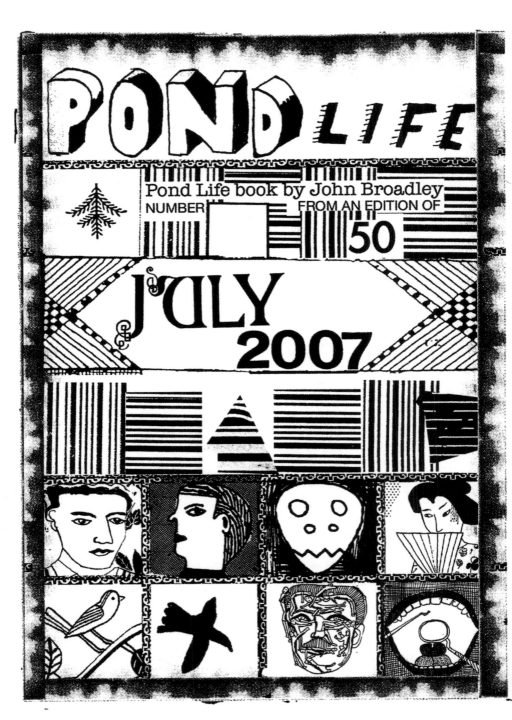

POND

LIFE

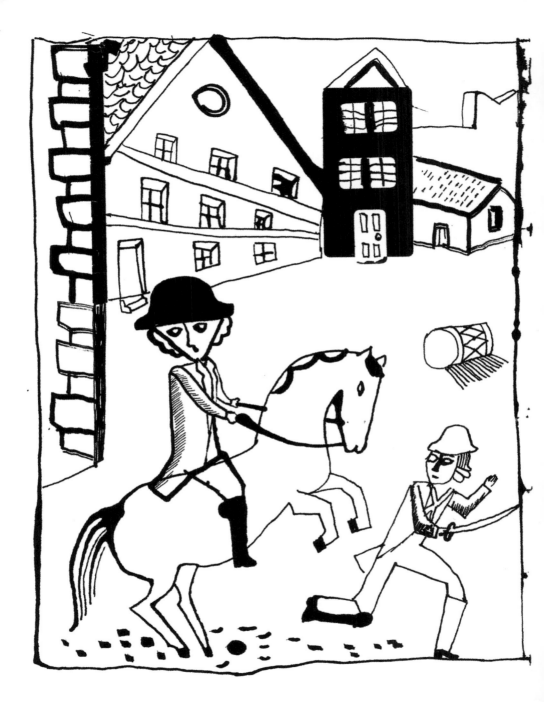

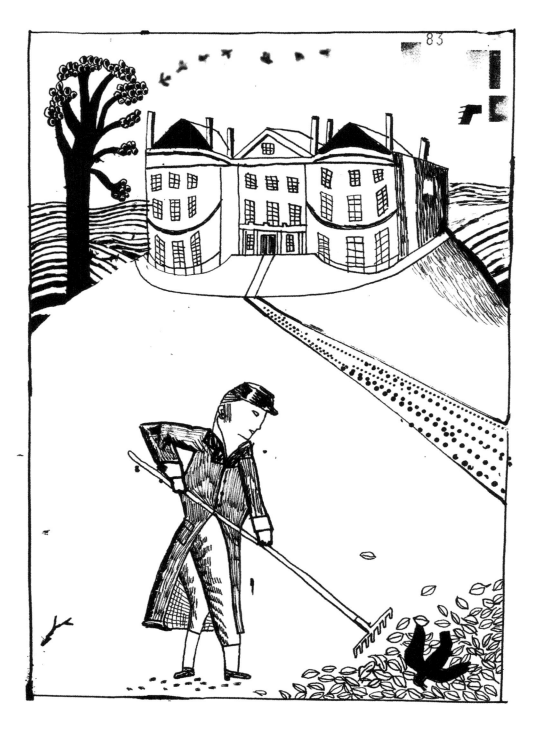

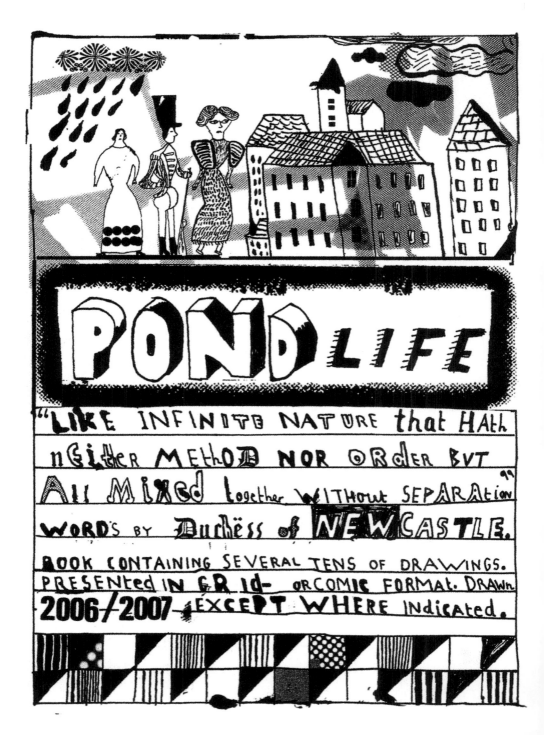

POND LIFE

"LIKE INFINITE NATURE that HAth nEither METHOD NOR ORDER BUT All MIXED together WITHOUT SEPARATion"

WORDS BY Duchess of NEWCASTLE.

BOOK CONTAINING SEVERAL TENS OF DRAWINGS. PRESENTED IN GRid- orCOMIC FORMAt. DRAWn 2006/2007 EXCEPT WHERE Indicated.

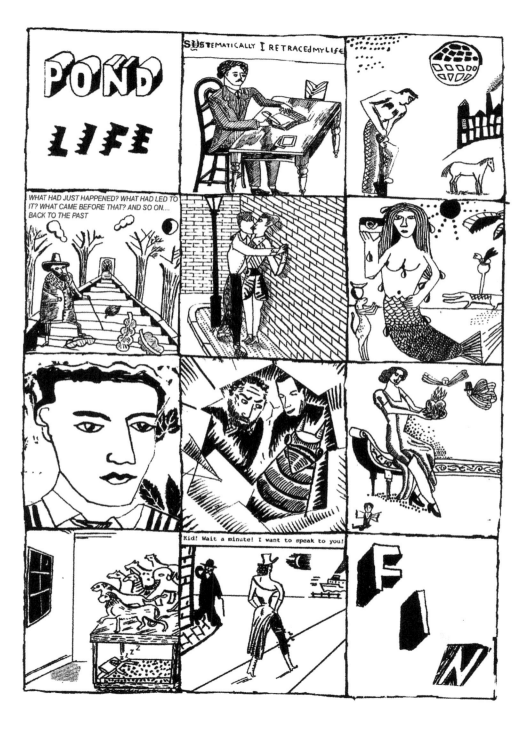

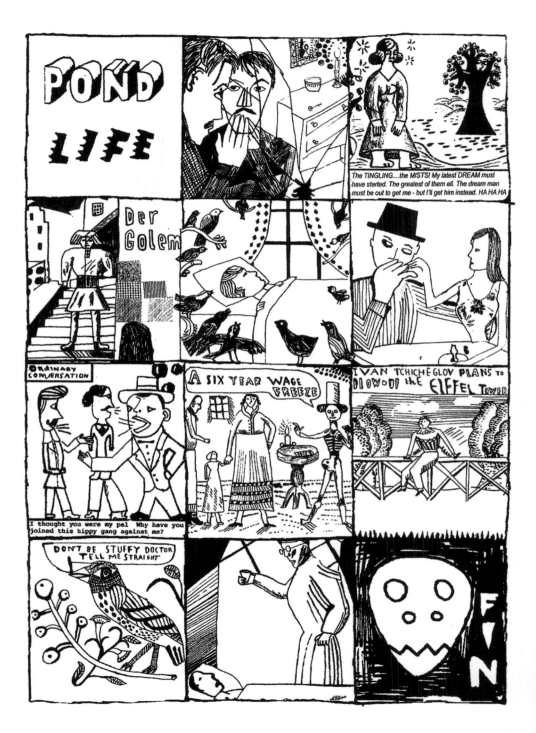

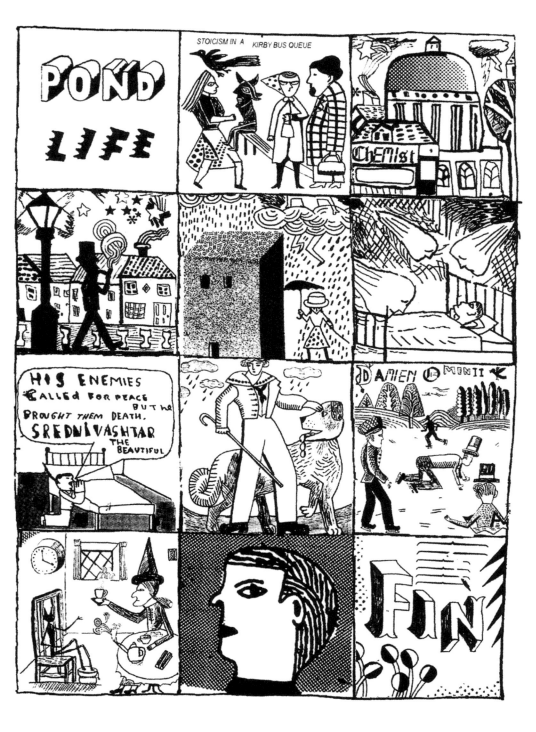

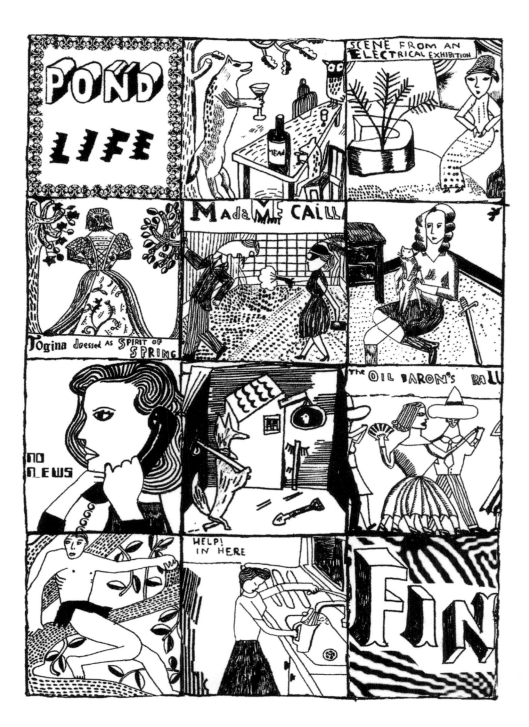

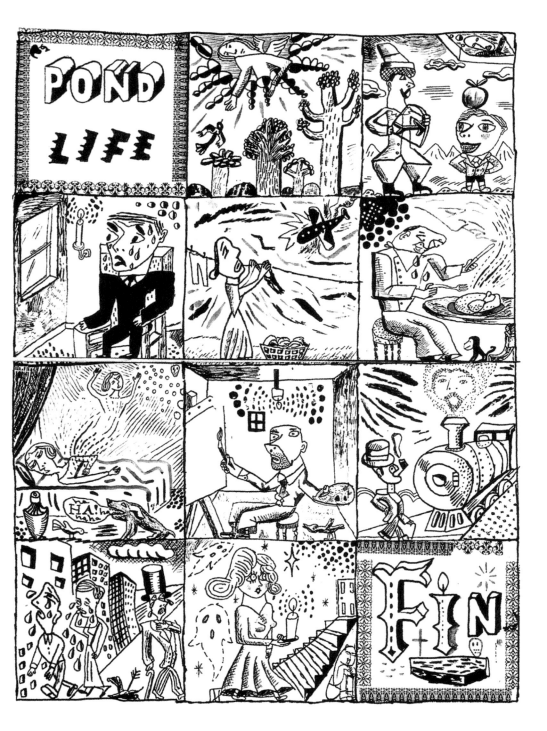

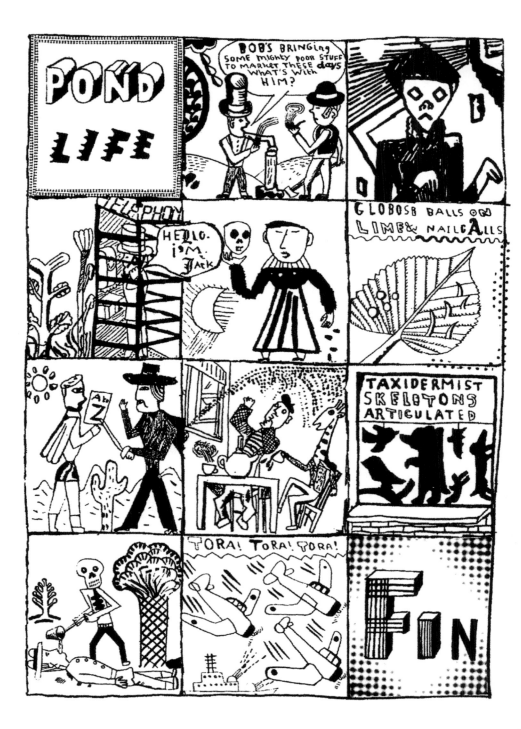

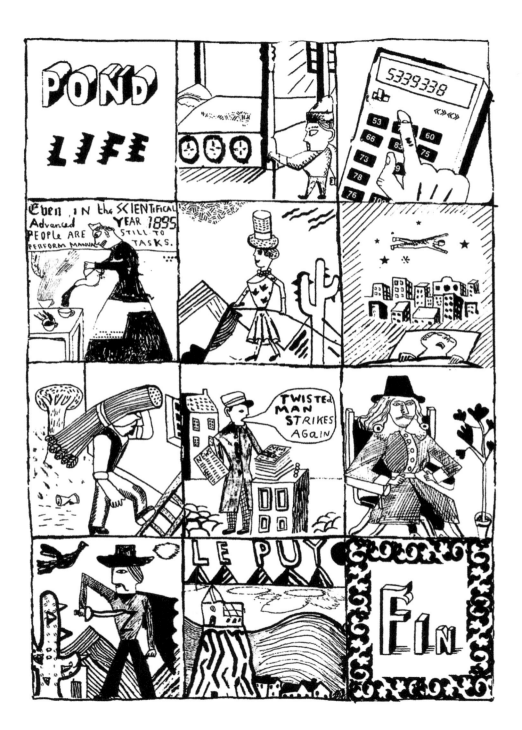

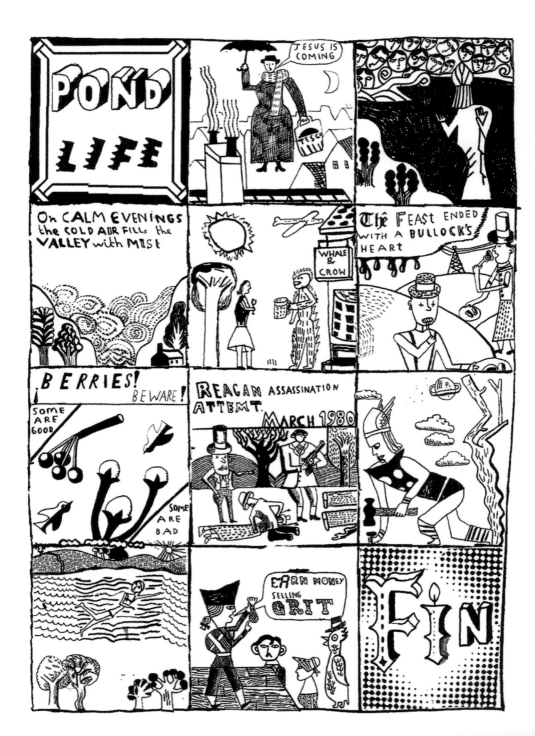

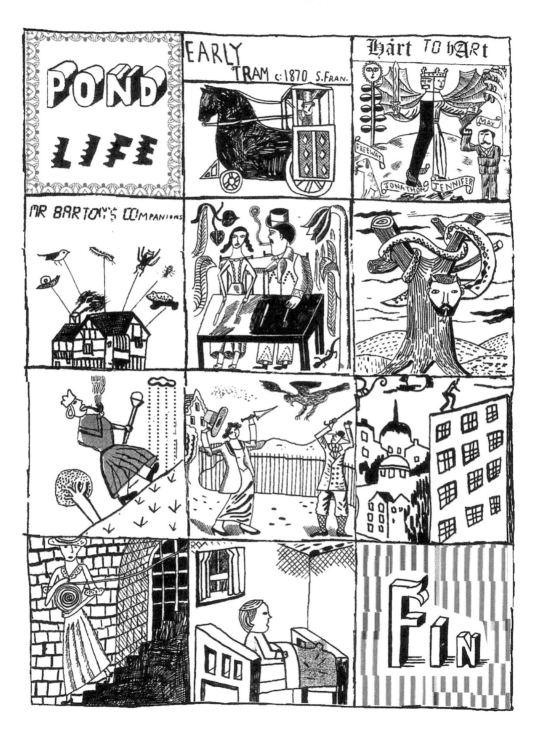

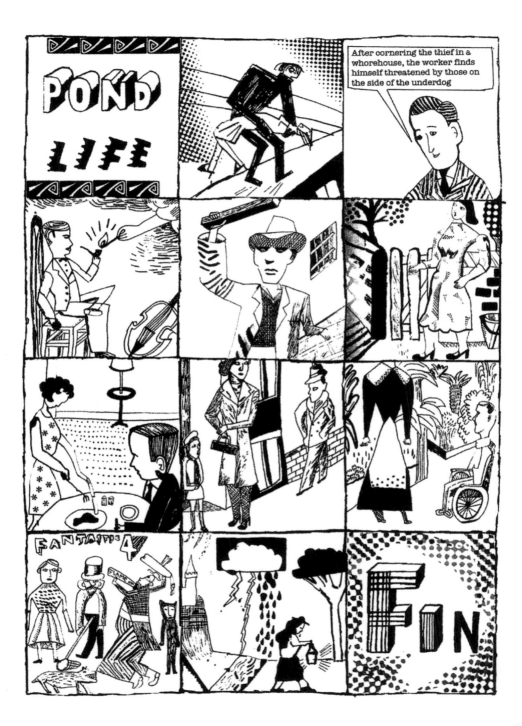

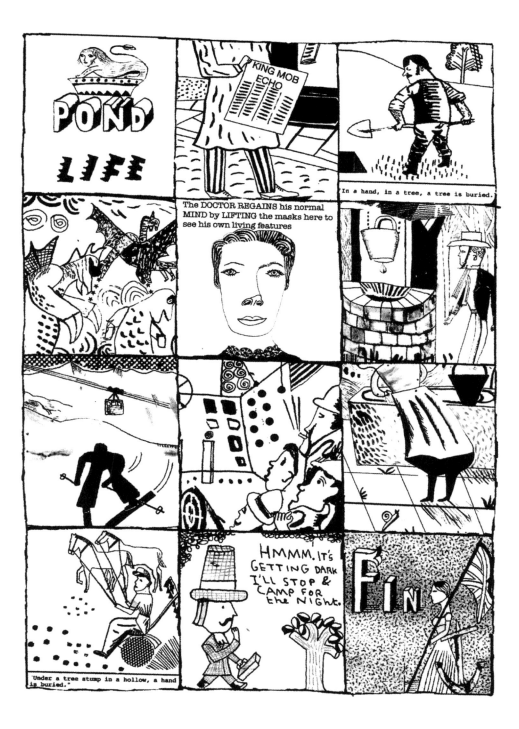

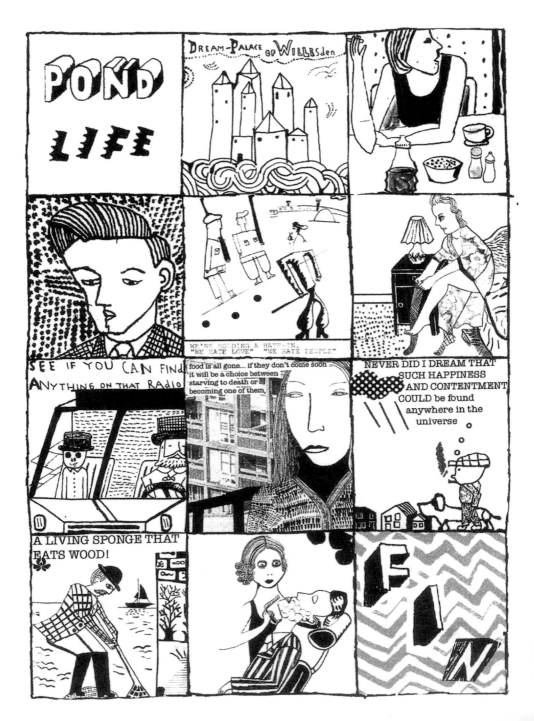

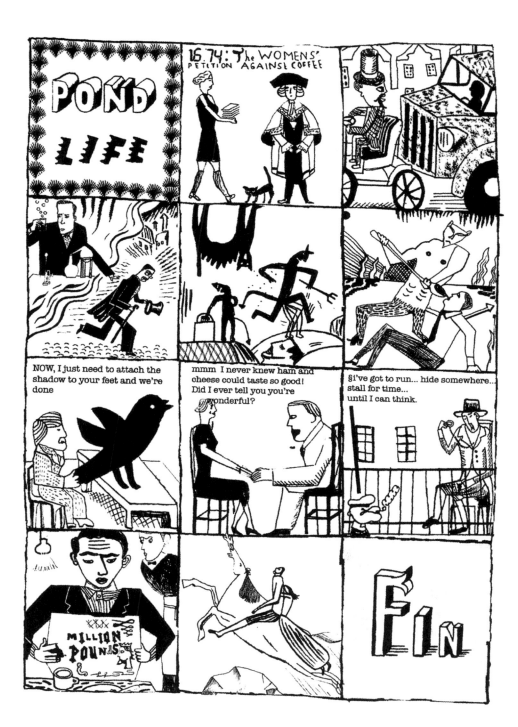

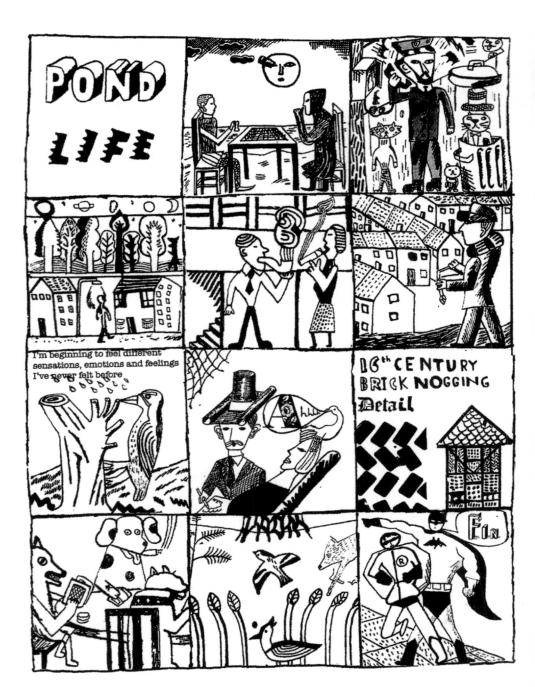

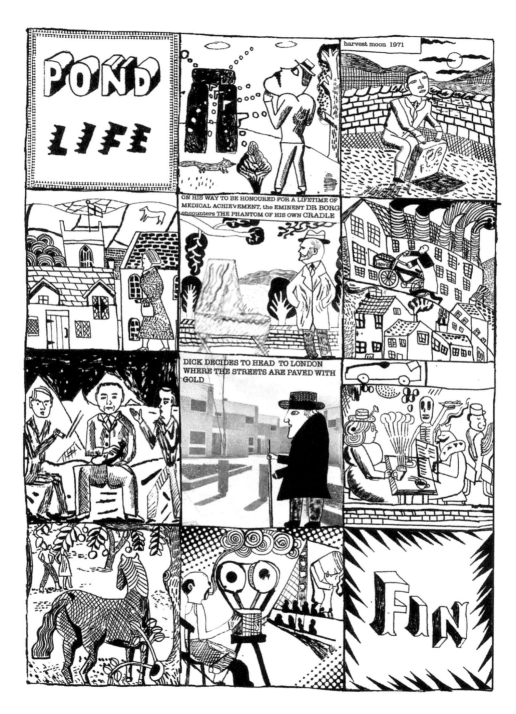

POND

LIFE

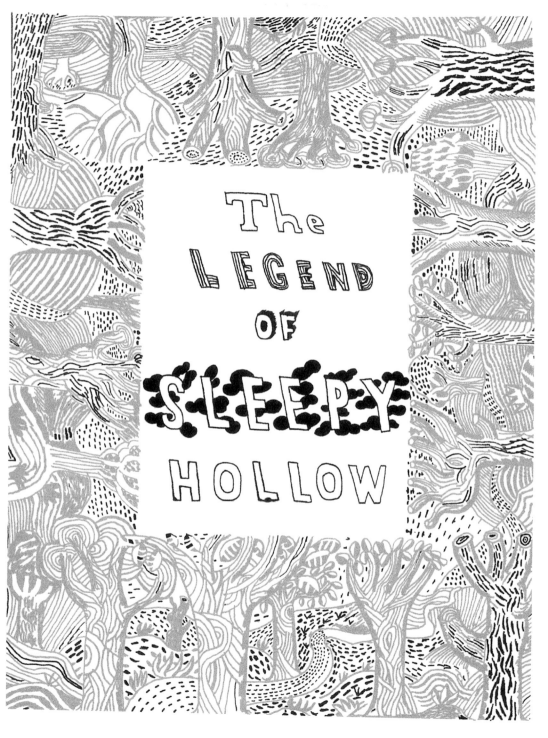

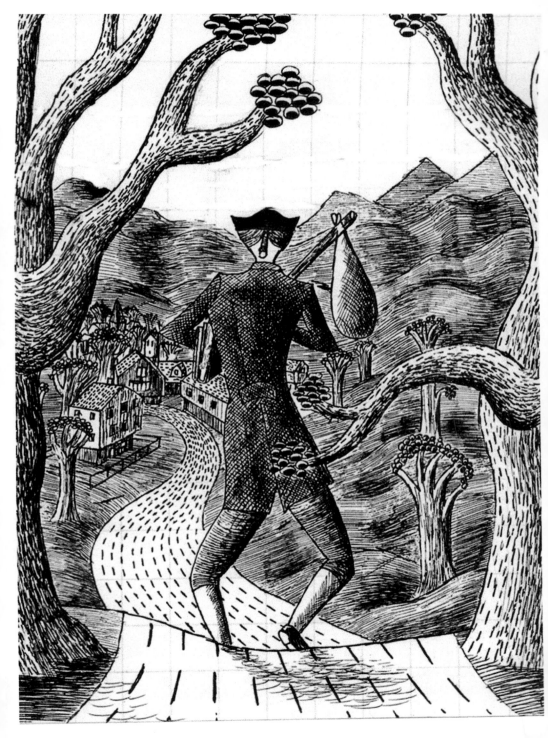

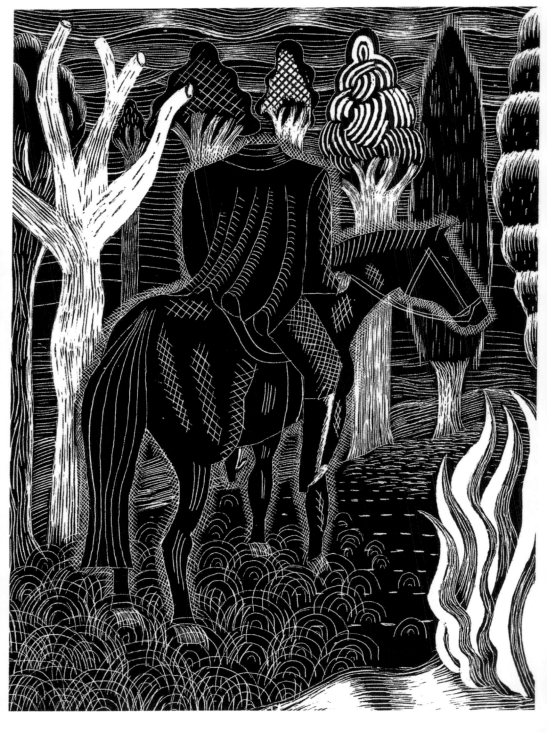

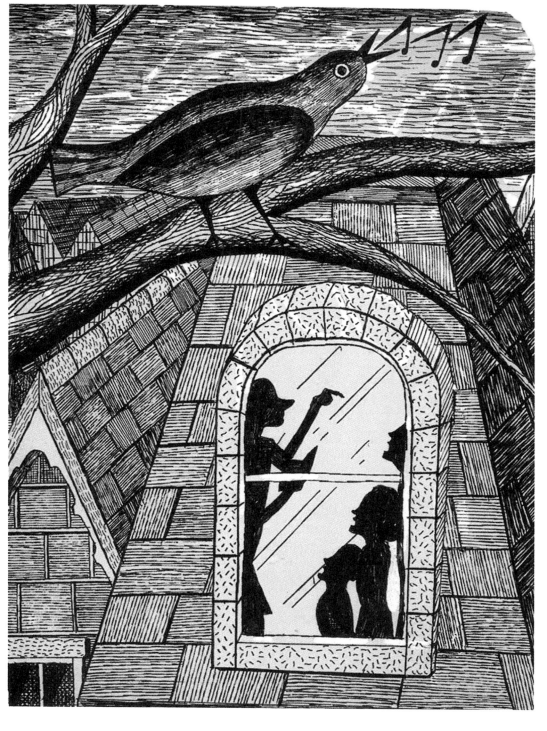

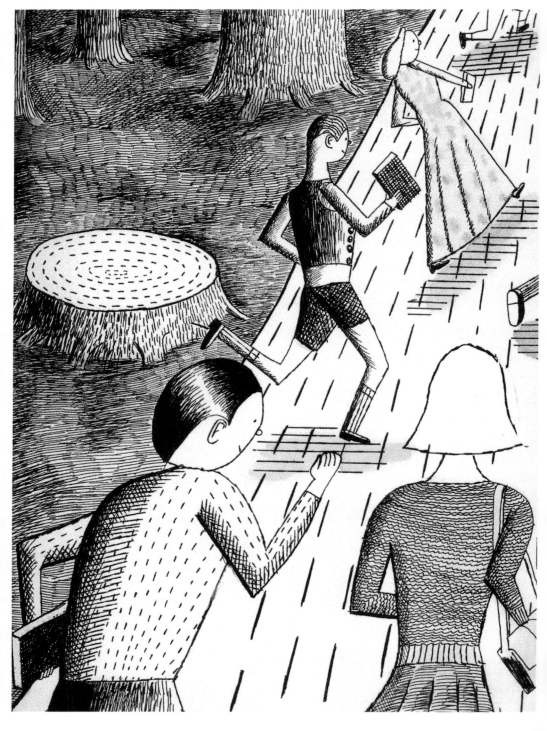

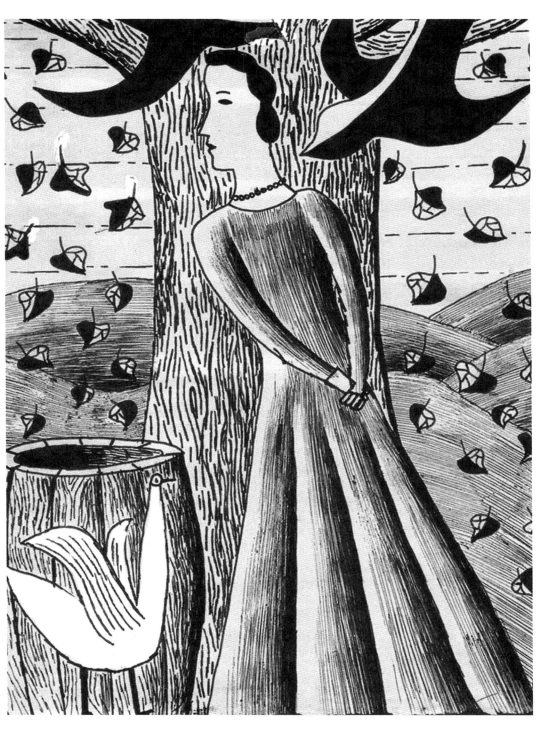

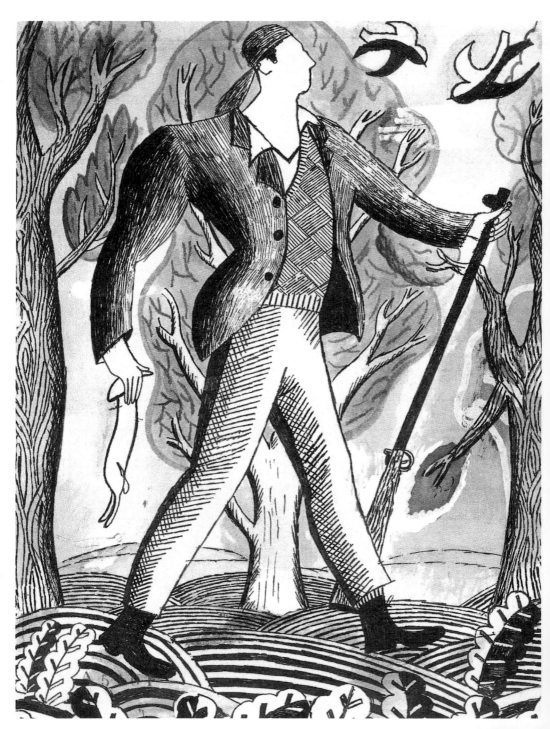

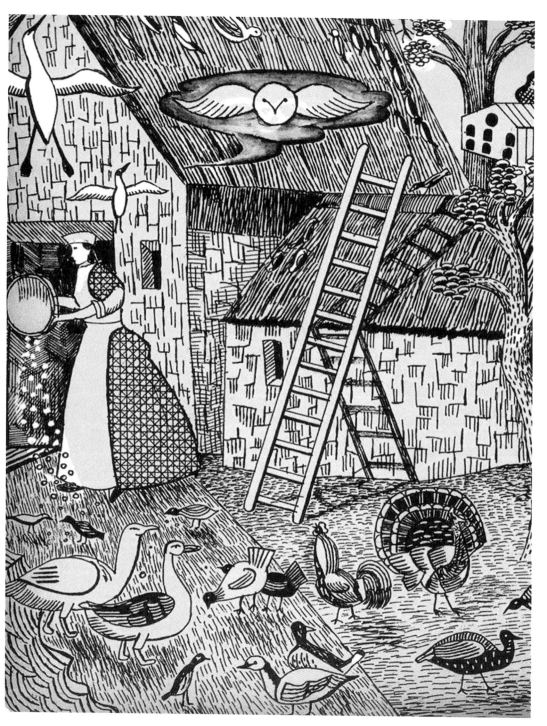

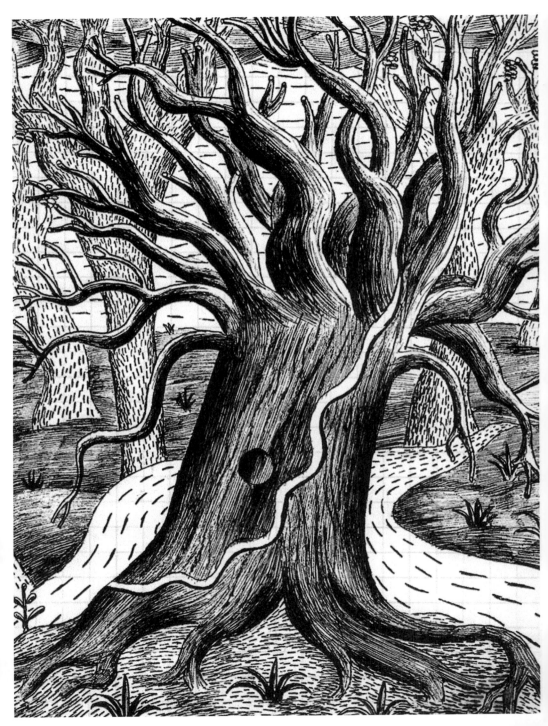

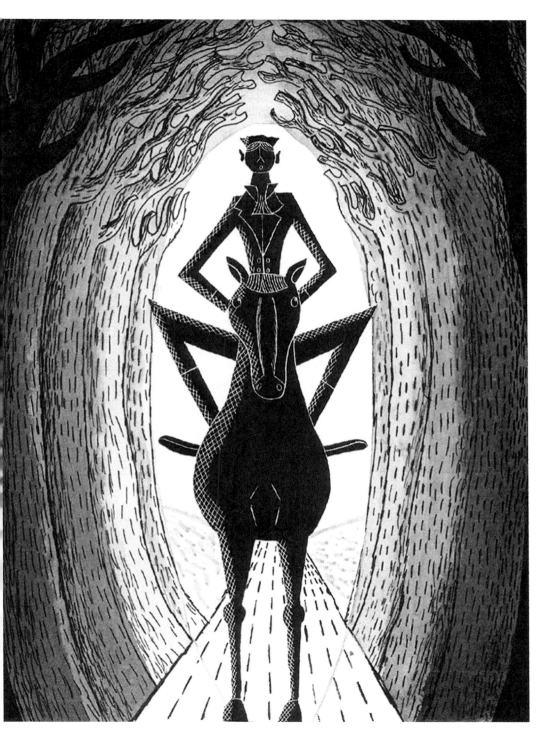

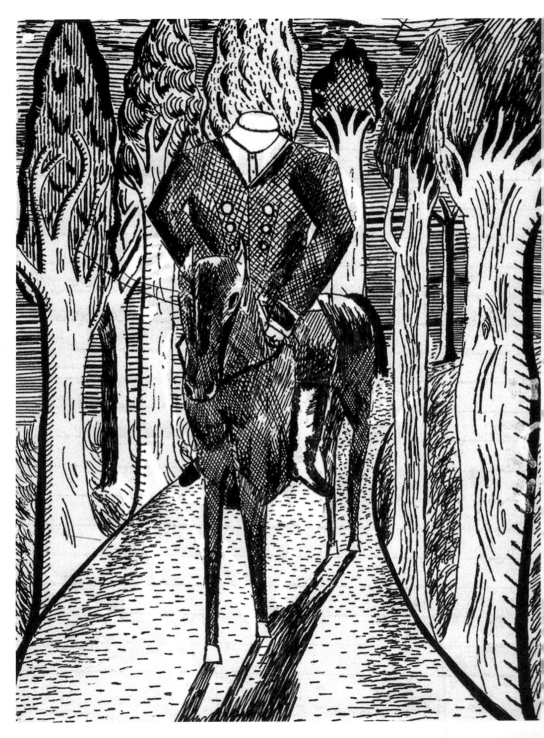

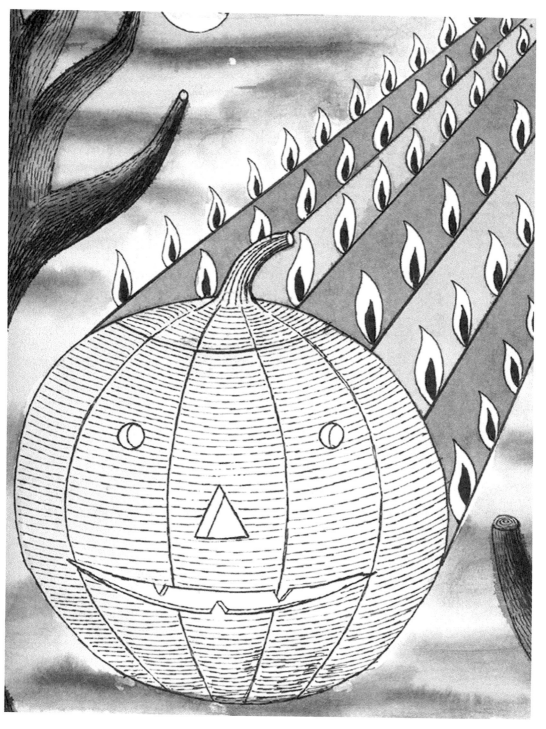

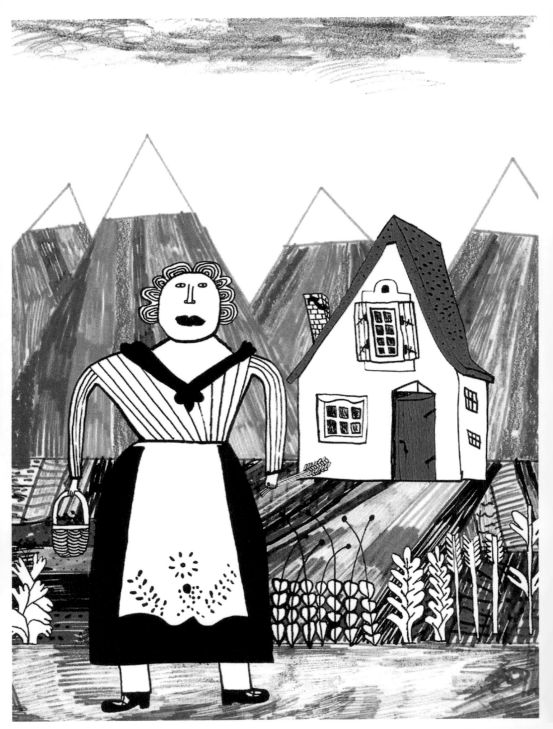

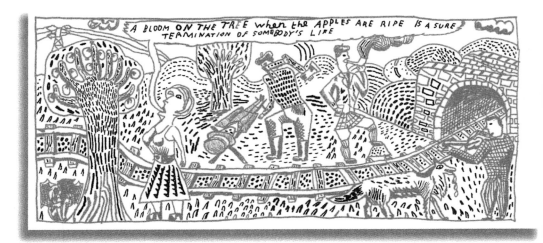

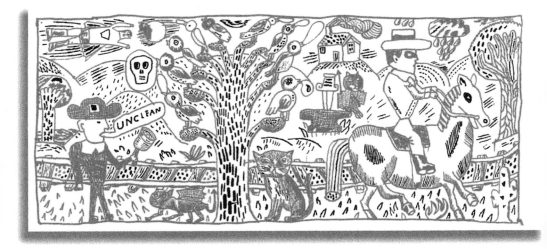

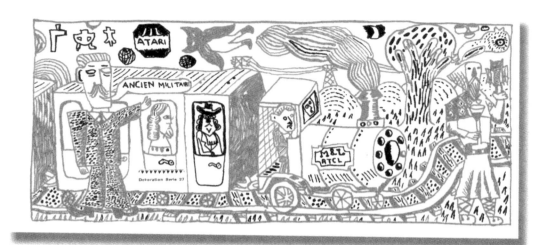

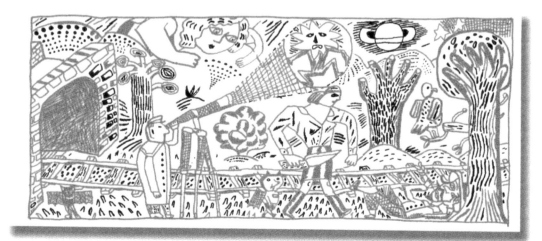

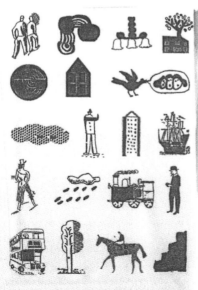

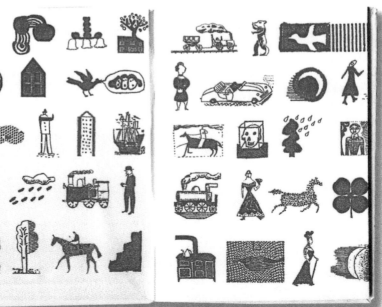

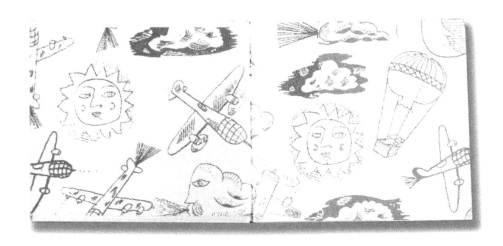

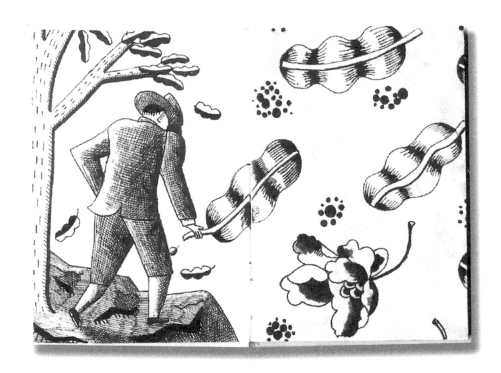

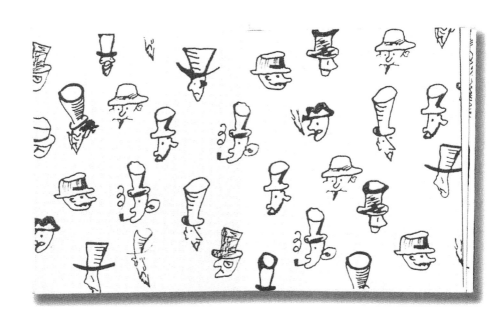

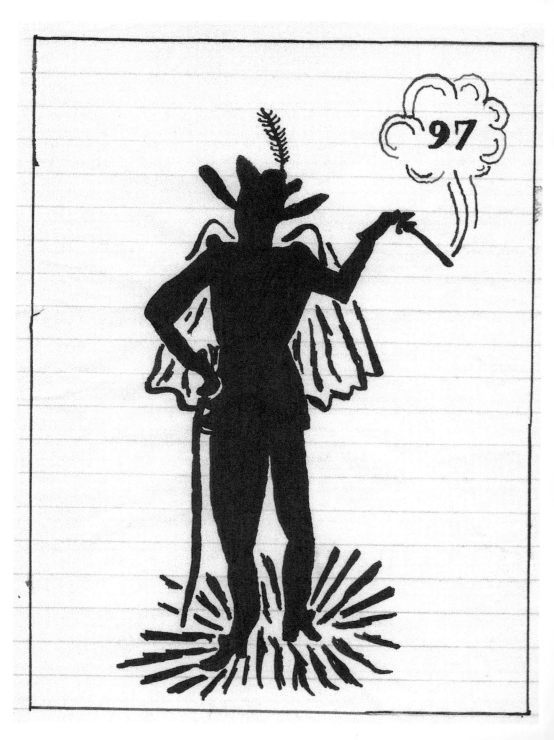

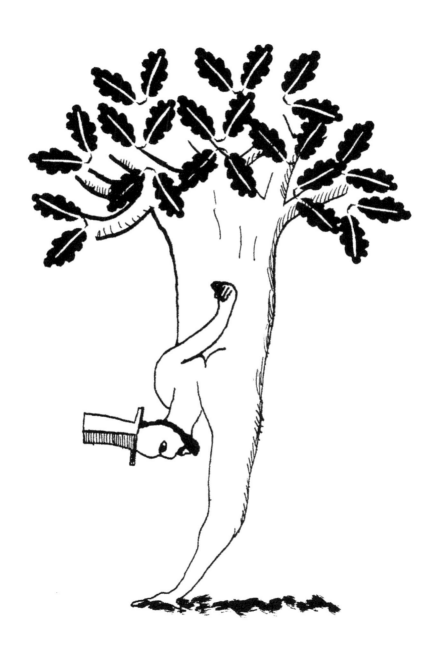